Long Branch

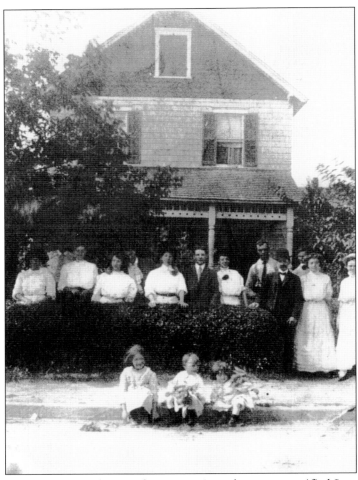

Besides the elaborate estates and magnificent mansions that so personified Long Branch in its golden years, there were many modest homes as well. They were the homes of the workers and business owners who kept the town running smoothly and its vacationers comfortable. This house, located at 264 West End Avenue, was built by Annie and Frank Brown in the late 1800s. The couple met while working as caretakers at Pres. Ulysses S. Grant's summer cottage on Ocean Avenue. Every Sunday, Annie hosted an after-church brunch at her little cottage where many of the local workers and townspeople would gather to relax. Annie is probably inside preparing her famous Irish bread, a baked ham, and potato salad for the group to enjoy. But her daughter Mary Beam is outside with her friends. She is the second woman from the left. Annie's grandchildren, William, Gertrude, and Dorothy Beam, are sitting on the curb along with the family chickens, Mollie and Moochie. This house is still on West End Avenue and looks much the same as it did in this photograph, taken in 1914. Annie's granddaughter Dorothy Williams still lives in Long Branch as do many of her great-, great-great-, and great-great-great-grandchildren. When Annie (Lenahan) Brown arrived from Ireland in the 1860s she thought Long Branch would be a good place to make her home.

On the front cover: Please see page 118. (Author's collection.)

On the back cover: Please see page 51. (Author's collection.)

POSTCARD HISTORY SERIES

Long Branch

Sharon Hazard

ARCADIA
PUBLISHING

Published by Arcadia Publishing
Charleston SC, Chicago IL, Portsmouth NH, San Francisco CA

Printed in the United States of America

Library of Congress Catalog Card Number: 2006935851

For all general information contact Arcadia Publishing at:
Telephone 843-853-2070
Fax 843-853-0044
E-mail sales@arcadiapublishing.com
For customer service and orders:
Toll-Free 1-888-313-2665

Visit us on the Internet at www.arcadiapublishing.com

CONTENTS

ACKNOWLEDGMENTS

I want to first thank my family who put up with many hours of my researching and writing and messy desk. I would also like to thank Pat Curley Schneider, the Long Branch Historical Association, and the Long Branch Library Local History Room.

This book is dedicated to a woman whose name is not readily recognizable as one of Long Branch's elite or famous, but it was men and women like her who helped make this city a wonderful place to vacation or live during its golden years. Her name is Anna Elise Lenahan Brown, Annie to friends and family. She arrived in Long Branch in the late 1860s from Limerick, Ireland, looking for work.

She was lucky to find a position. For many summers she worked as a domestic in the summer cottage of Pres. Ulysses S. Grant and his family. His home was located at 991 Ocean Avenue in the Elberon section of town. He owned the home from 1869 to 1884.

While working there, Annie met Frank Brown, a groundskeeper for the Grant family. They eventually married and built a small home at 264 West End Avenue. The house is still at that location. The only things missing are the honeysuckle bush that climbed up the lattice on the front porch and the rocking chairs that welcomed company and conversation. An Irish housekeeper working for a United States president was able to make enough money to stay in America, build a home, and raise a family. She was also able to contribute funds to help build a church. St. Michael's Roman Catholic Church was only a small wooden structure with a dirt floor when she and some of her friends worshiped there.

Because of regular women like Annie Brown, famous people like President Grant were able to live in Long Branch and make it known as the Summer Capital. Also because of Annie Brown, I am happy to be a fourth generation resident of Long Branch. She was my maternal great-grandmother.

INTRODUCTION

All aboard, and welcome to Long Branch. This book is going to take you on a trip to another time, but not another place. The place remains the same; it is the town of Long Branch. Although more than 100 years have passed since many of these postcards and pictures were written, sent, or photographed, the basis of their subject remains unchanged. The Atlantic Ocean and the sands it washes up to have not changed in all these years. The boardwalk that stretches along its graceful bluff has been rebuilt many times, but people still enjoy strolling on it and enjoying the view and fresh breezes. Ocean Avenue is now paved and busy with cars and traffic, but it is still the road that takes you from the south end of the city to the north.

As our trip meanders through town, you will notice that the streets still have the same names that they did when Long Branch was the premier resort on the East Coast. Brighton, Bath, and Chelsea Avenues still run from Ocean Avenue west. These streets, as well as a section of Long Branch called West End, received their names from an area in the west of England called Brighton that had the same typography. It rests on a bluff over the sea. That is how West End, Long Branch, got its name. Lincoln and Pullman Avenues and Garfield Terrace in the Elberon section got their names from some famous men who resided there. Lincoln Avenue is named for Robert Todd Lincoln, the son of Pres. Abraham Lincoln, who was secretary of war under Pres. James Garfield. Garfield Terrace is named for James Garfield, the president of the United States, who was brought to a seaside cottage at the end of this street in hopes that the ocean air would bring about his recovery after an assassin's bullet had critically wounded him. Pullman Avenue is named for George Pullman, the owner of the Pullman Palace Railroad Car Company. He owned several homes in town and helped to raise the money to purchase a summer home for Pres. Ulysses S. Grant. Grant's summer cottage was located at 991 Ocean Avenue in Elberon.

Known as the nation's watering hole because of its socially acceptable clientele, it was the place to be, especially in the summer. Many of these names are readily recognized. Starting with the visit of Mary Todd Lincoln in the summer of 1861, Long Branch received the seal of approval as a place to vacation. Seven United States presidents lived or vacationed here, actors and actresses purchased homes here, business tycoons invested heavily in real estate, and the wealthy from Philadelphia and New York City came here to take advantage of the seashore and socializing.

Call it a trip down memory lane or just a pleasant reminder of what life was like in Long Branch, this book will give readers of today a glimpse of yesterday.

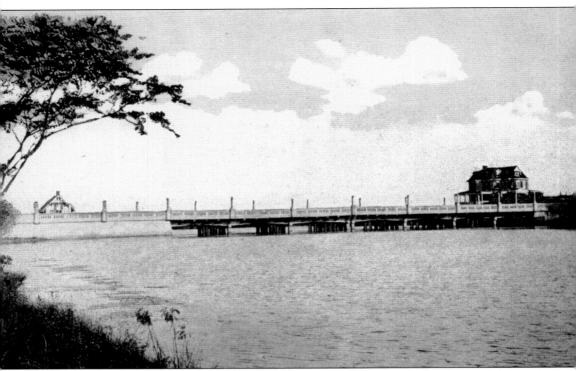

This is the United States Life-Saving Station 5. Sitting on the shoreline across the street from Takanassee Lake can be seen three buildings representing various eras of the United States Life-Saving Service, the model for today's Coast Guard. These three buildings were the original headquarters for the volunteer lifesaving crew. The oldest dates from 1878, the second was designed in 1897 as living quarters for the men, and the third, a boathouse, was built in 1903. Only one other site in the country has as many life-saving service buildings on its property, it is in Michigan and has been designated a national park. These historic buildings are now part of the Takanassee Beach Club property. One of these buildings was used as a private home for the Peters family, owners of the beach club.

One

THE BEACH,
THE BOARDWALK, AND
OCEAN AVENUE

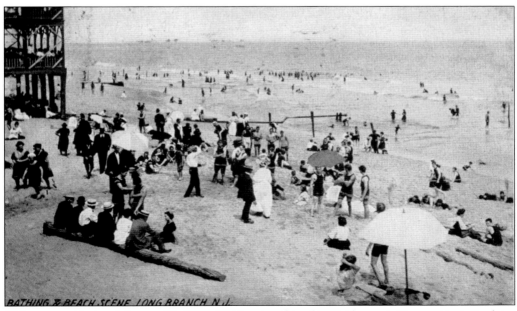

BATHING & BEACH SCENE LONG BRANCH N.J.

This postcard is dated August 30, 1910. Written to a friend in Bridgeport, Connecticut, it relates days of hard work in anticipation of an opening. Most likely it was referring to a theatrical production. Long Branch's cool breezes and prominent visitors attracted many actors from New York and Philadelphia.

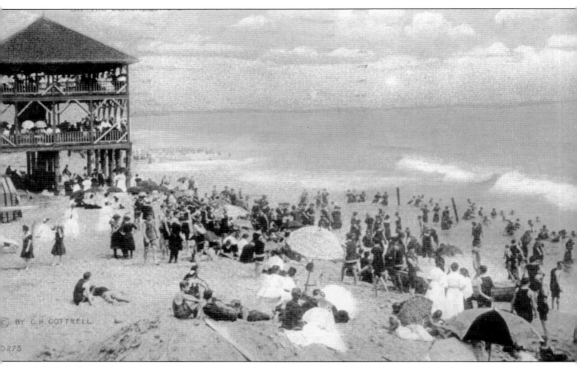

On July 19, 1912, Frank Campana wrote a friend in Jersey City that he was enjoying the beach in Long Branch. His return address was listed as 274 First Avenue, Long Branch, New Jersey. That street was located east of Second Avenue. It is no longer there.

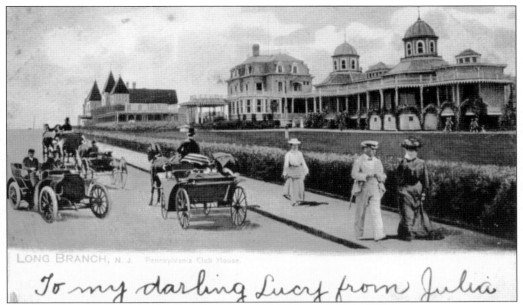

LONG BRANCH, N. J. Pennsylvania Club House.

To my darling Lucy from Julia

In the late afternoon on a summer day, the fashionable thing to do was go strolling or driving along Ocean Avenue. This postcard dated August 27, 1900, was a typical scene in front of Phil Daly's Pennsylvania Club located on the corner of Brighton and Ocean Avenues. The gambling casino took up the south side of the street from Second Avenue to Ocean Avenue.

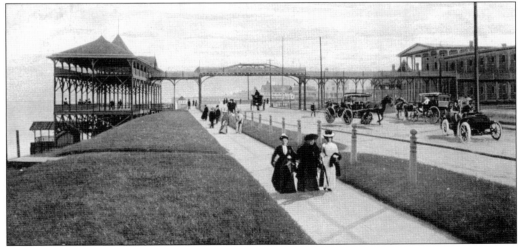

Three women are walking in front of the West End Hotel. In the 1890s it was not socially acceptable for single women to vacation without a chaperone, and the woman in the middle of the group is probably an older woman hired for the purpose. Located on the west side of Ocean Avenue, just north of Brighton Avenue, the hotel grounds were arranged as an extensive park with many adjoining buildings, including a summer auditorium and a bridge providing guests access to a shaded pavilion overlooking the beach below.

11

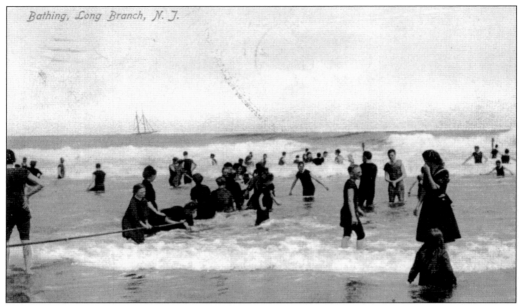

Dated 1907, this postcard shows a delighted group of waders cooling off at the water's edge and the more experienced swimmers venturing into the waves. No matter how far out into the water one went or how hot it was, women were modestly dressed in woolen swimming dresses and men wore woolen bathing suits.

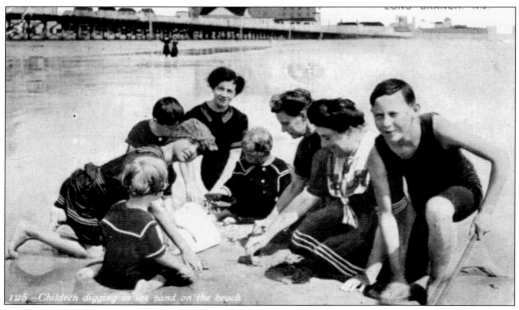

A family enjoying a day at the beach provides a closer look at the bathing attire of the day and the happy faces of the children digging in the sand. Bathing suit styles have changed over the years, but the joy of a child digging in the sand remains the same.

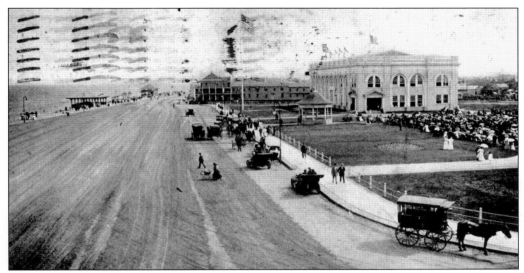

Ocean Avenue is still an unpaved road in this postcard dated June 8, 1909. The scene is looking south with the casino and Ocean Park on the right and the beach and boardwalk on the left. The center of activity along the shore was Ocean Park, a 10-acre park of flower beds and fountains with a bandstand for afternoon concerts. In 1907, a casino and convention hall seating an audience of 3,000 was erected at a cost of $50,000. The old casino, which became the Casino Annex, was the Agricultural Hall at the Centennial Exposition of 1876 in Philadelphia. It was brought to Long Branch in 1877. During World War I, the Casino Annex was used as a Red Cross workroom and encampment for soldiers. In 1919, it became a recreational center for soldiers injured in combat.

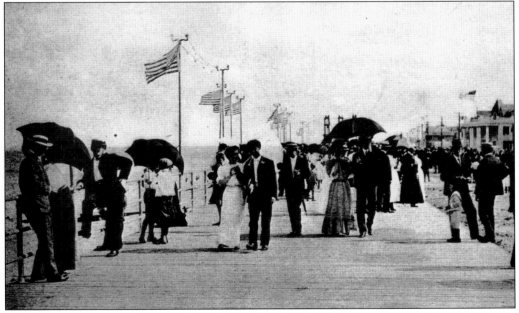

Couples are seen taking a walk along the wooden boardwalk. They are headed north and the casino and Ocean Park can be seen behind them. Possibly they have just attended one of the afternoon concerts held there.

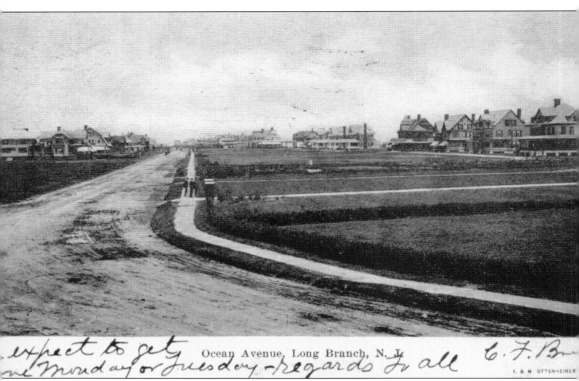

expect to get ...ne Monday or Tuesday - Regards Fr all Ocean Avenue, Long Branch, N. J. *C. F. B...*

I. & M. OTTEN-EIMER

In 1885, Ocean Avenue remained an unpaved road, nevertheless a well traveled and much admired one. All of the main streets in the city that headed east ended up on Ocean Avenue. Everything from roads to people gravitated to the ocean and the road that ran past it from north to south. The three men in the photograph seem to be admiring the beautiful homes along the bluff.

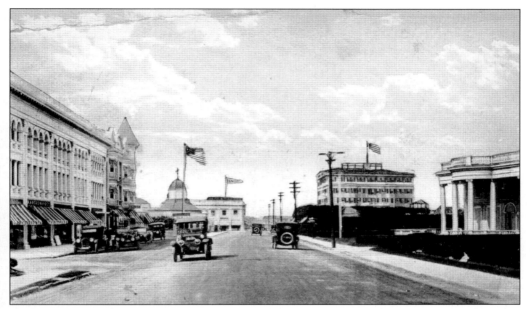

Ocean Avenue in West End looking north shows the multitude of businesses once located there. Huyler's Candy Shoppe is seen on the right. Huyler's, along with many other businesses from New York City, opened shops in Long Branch so that vacationers from there could still take advantage of their top-of-the-line products.

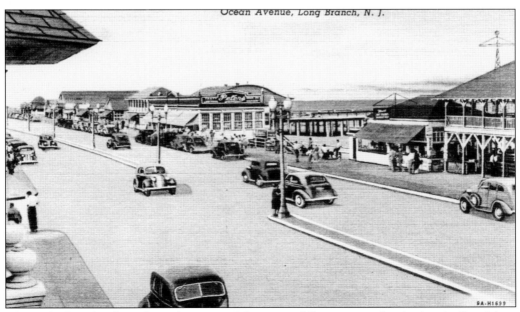

This is the boardwalk in the early 1900s. If the automobiles were modernized and a few things changed, one could imagine this being a photograph of Pier Village today.

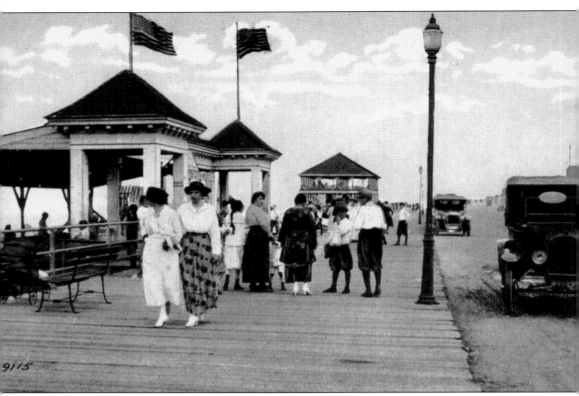

This *c.* 1910 postcard shows some changes along the boardwalk; women are now walking unescorted, the grass path has been replaced by wooden planks, and automobiles have replaced horse and buggies, but the road still remains unpaved.

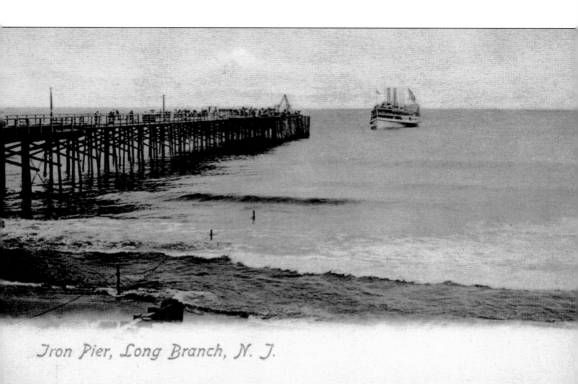

Iron Pier, Long Branch, N. J.

This postcard identifies the structure on the left as the iron pier. Through the years, there were many piers built in Long Branch. In 1911, work began on Long Branch's fifth pier. It was built by Samuel Rosoff, contractor for many of the New York City subways. Plans for this pier were on a grand scale. It was intended to reach far enough into the ocean for steamers running from New York to dock. A dance hall, theater, and amusements were also planned. Funds ran out, and the pier was never completed.

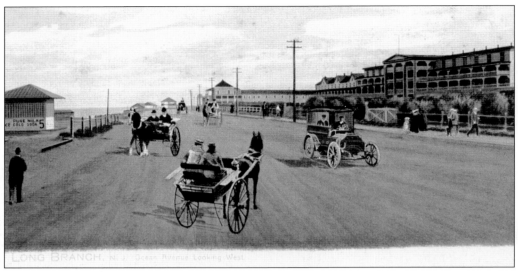

Ocean Avenue is an unpaved dirt road in this postcard. The first automobiles, sometimes called horseless carriages, seem comfortable riding alongside the fashionable horse and buggies. The United States Hotel is on the right-hand side. Facing south, this postcard shows a small concession stand on the left advertising pure milk and ice-cold soda at 5¢ a serving. Telegraph poles dot the side of the street.

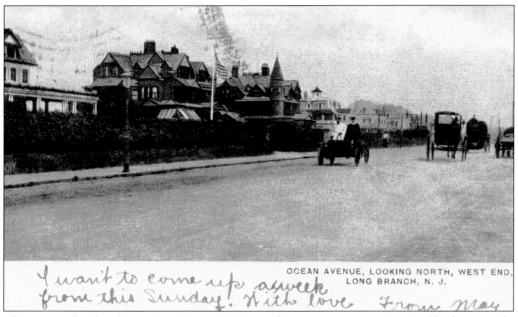

This postcard is dated June 10, 1907. It is a scene of Ocean Avenue in West End looking north. Shingle-style summer cottages and manicured hedges line the street. Horse and buggies seem unimpressed with the electric car headed south.

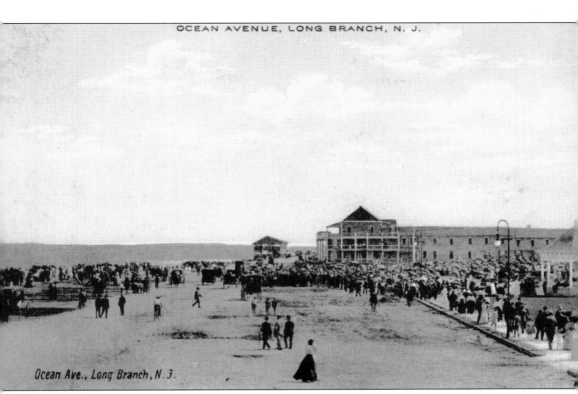

Ocean Ave., Long Branch, N. J.

Every afternoon there was a band concert in Ocean Park located on Ocean Avenue, just south of Broadway and adjacent to the casino. It was a time of day when everyone left the beach, got dressed up, and hurried across the street to enjoy some of the culture the city had to offer. The note on the back of this undated postcard reads, "Having the time of my life."

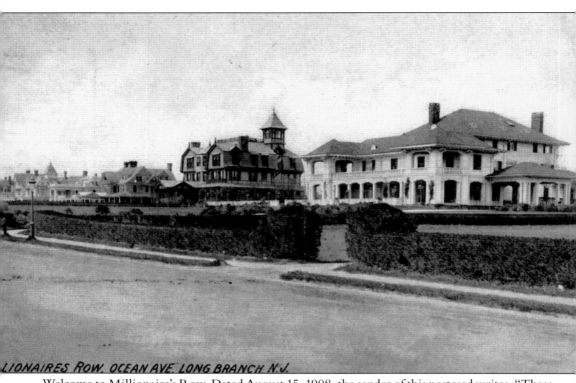

LIONAIRES ROW, OCEAN AVE, LONG BRANCH N.J.

Welcome to Millionaire's Row. Dated August 15, 1908, the sender of this postcard writes, "These large houses are all along the oceanfront for miles." Known as cottages, these homes were built to enjoy a relaxed summer lifestyle and take advantage of the summer breezes. These homes were located just south of Takanassee Lake, heading into Elberon.

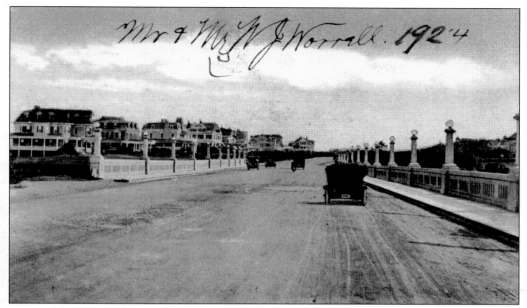

A graceful bridge looking south over the Takanassee Lake is the entrance to the Elberon section of Long Branch. This postcard is dated 1924. Large summer estates form a long line of majestic architecture along the ocean.

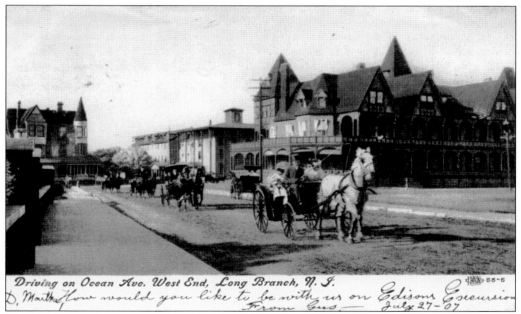

Dated July 27, 1907, the scene is along Ocean Avenue in West End. Many of the larger hotels had stables on their grounds in order to board the horses that were brought to town by prominent out-of-town summer residents. Some of these stables had accommodations for 150 horses and advertised their superior ability to take care of them by listing stable supervisors among the executives. The size and stature of the team of horses and appointments of their carriages were signs of how wealthy their owners were.

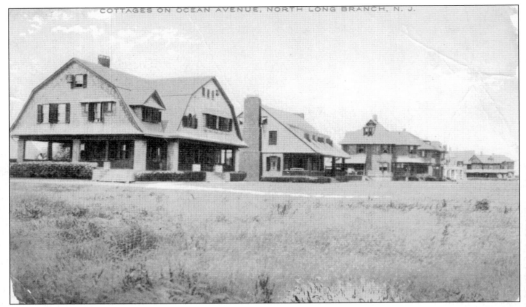

All of the homes along the oceanfront were not grand mansions, but were very appealing in their simple style and lofty location. These cottages were located along the oceanfront in North Long Branch.

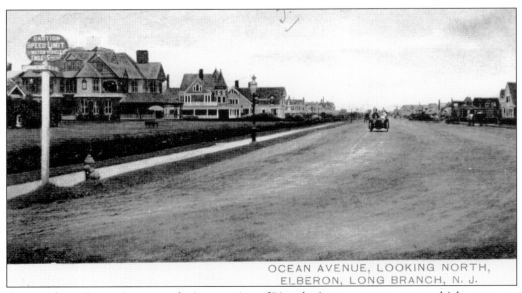

A scene along Ocean Avenue at the intersection of Lincoln Avenue warns motor vehicle operators to watch their speed. The sign reads "Caution. Motor vehicle speed limit one mile per hour."

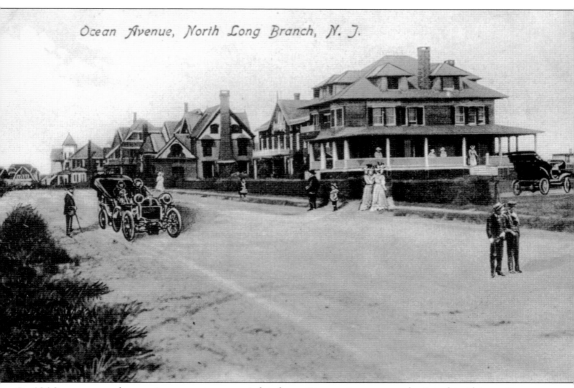

Ocean Avenue, North Long Branch, N. J.

In 1908, cars were becoming a customary sight along Ocean Avenue, as depicted in this section of North Long Branch.

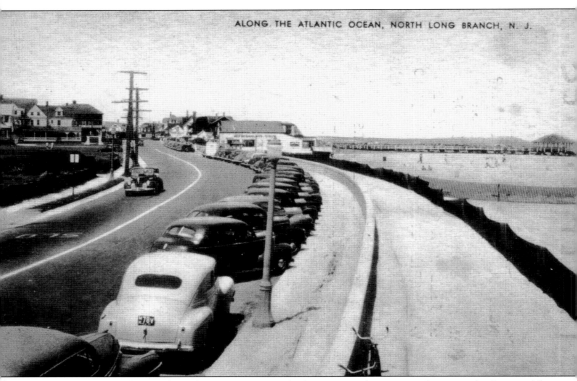

Parking along the beach in the summer was a little easier in the 1930s. These cars had no problem finding space in North Long Branch where Seven Presidents Park is now located.

Two

ALL AROUND TOWN

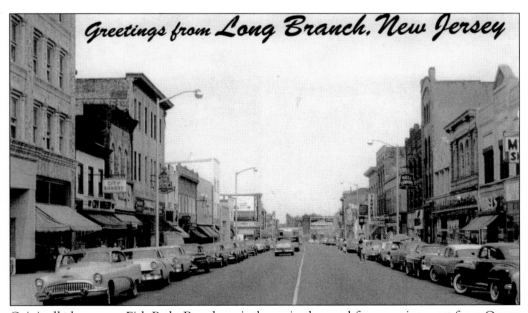

Originally known as Fish Path, Broadway is the main thoroughfare running west from Ocean Avenue. In this 1950s scene a busy section of the street shows stores and businesses, including the City Bakery that made the best birthday cakes in town.

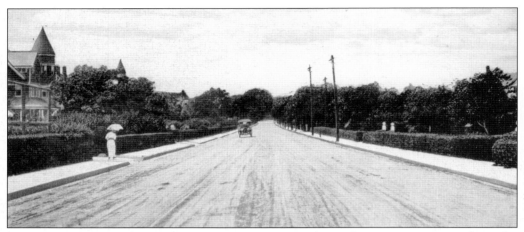

Running east to west from Ocean Avenue to Monmouth Road in West Long Branch, Cedar Avenue was one of the most prominent addresses in Long Branch. Large homes and hotels bordered the wide street. It received its name because of the groves of cedar trees that grew in the open fields that surrounded the avenue.

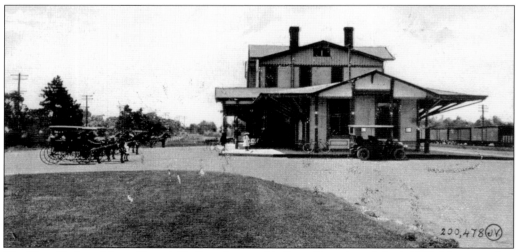

The New York and Long Branch Railroad opened in Long Branch on July 4, 1875. Now travelers had a more direct route to the shore via the train. This undated postcard shows the Long Branch Train Station with carriages lined-up to meet the summer crowds and take them to their homes or hotels. Located on Third Avenue, a modernized station is still there.

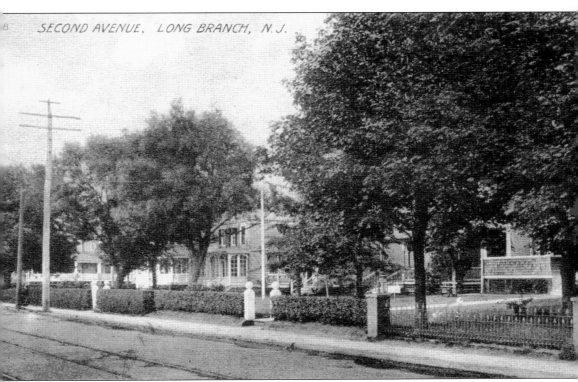

SECOND AVENUE, LONG BRANCH, N.J.

Trolley tracks can be seen running along Second Avenue from north to south. Horsecar drivers, threatened by the competition, called the trolleys "cheese boxes on wheels with hand brakes." The trolley line connected many cities along the shore and speeded the development of many outlying areas.

Long Branch rests upon a five-mile long bluff overlooking the Atlantic Ocean. The bluff provides a buffer between the sea when angry and the neighborhoods fronting Ocean Avenue. Through the years erosion has pushed the bluff and many of the hotels and bathing shacks situated there farther and farther back. These bluffs resemble a section in the west end of England that has similar typography. That is how the section of town called West End got its name. Several streets are also named after towns bordering this section of England. They are Brighton, Chelsea and Bath Avenues.

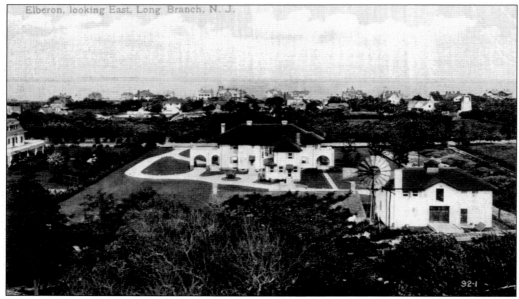

This bird's-eye view shows Elberon Avenue looking due east. The ocean can be seen as well as a Spanish-style home called Mia Casa that still looks much the same.

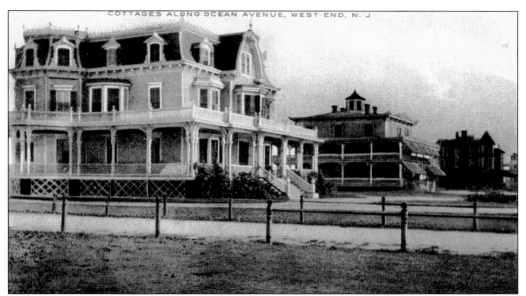

These Queen Anne–style homes gave Ocean Avenue in West End a look of wealthy stability.

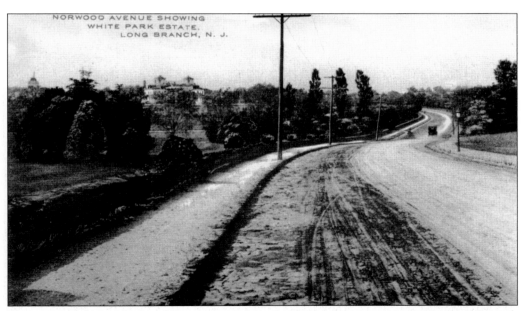

NORWOOD AVENUE SHOWING
WHITE PARK ESTATE.
LONG BRANCH, N. J.

This postcard shows Norwood Avenue headed north. This street now separates West Long Branch from Long Branch. The home in the upper left hand corner was known as White Park Estate. It was owned by John A. Postage Stamp White, nicknamed "Postage Stamp White." He made his millions by placing 2¢ stamps on envelopes. This house later became known as Shadow Lawn. Monmouth University's Wilson Hall sits on this spot now.

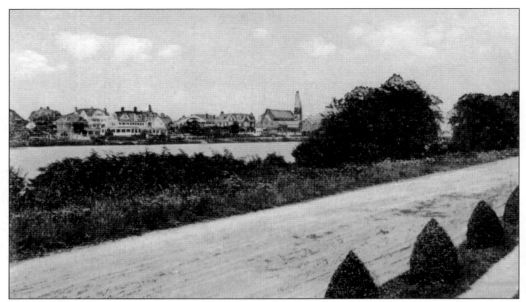

An oval drive and palatial homes surround Lake Takanassee. The drive is facing east towards Ocean Avenue. St. Michael's Roman Catholic Church can clearly be seen in this photograph.

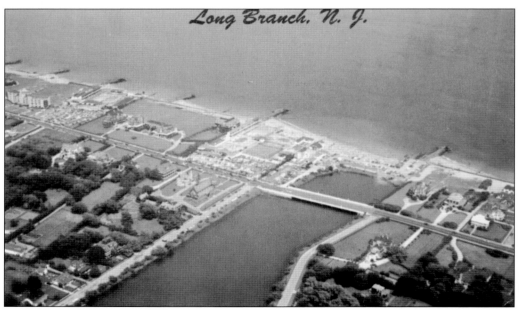

Long Branch, N. J.

Looking east before the high rises became part of the skyline, St. Michael's Roman Catholic Church was the tallest building along the Long Branch coastline. Airplanes coming into New York used the church's red spires as landmarks. Dated 1915, the note on the back of this postcard, written by a domestic worker, notes that a plumber was installing gas piping in one of these homes.

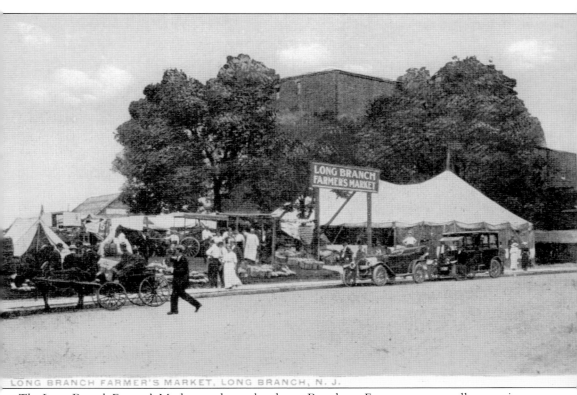

LONG BRANCH FARMER'S MARKET, LONG BRANCH, N. J.

The Long Branch Farmer's Market was located on lower Broadway. Farmers set up small concessions under tents to sell their locally grown produce that included Jersey corn and tomatoes as well as strawberries and grapes. Poultry and dairy products were also sold here.

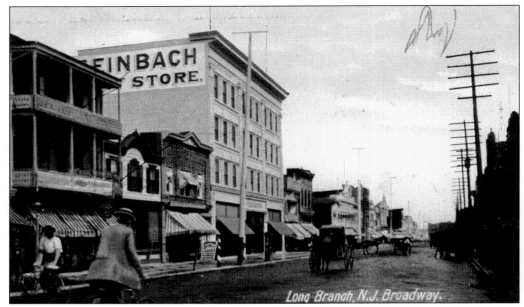

Looking east, this 1909 view of Broadway is quite impressive. A well-known dry goods store in Long Branch was Steinbach Brothers. It was founded in 1870 by John Steinbach. He started as a pack peddler with $25 worth of goods in a basket. He called his original store a "Temple of Fashion" and had his brothers come to America from Bohemia to join him. John and his brothers were among the most successful merchants along the shore.

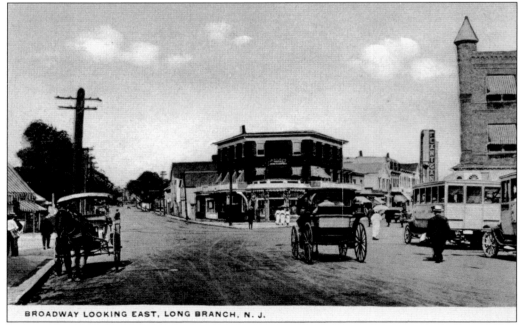

BROADWAY LOOKING EAST, LONG BRANCH, N. J.

This is a view of Broadway and Second Avenue looking east. It is the area now known as South Broadway, and the diamond shaped parcel at the intersection is still a prominent part of the landscape.

Except for a plot in Montclair, which is six feet square, at one time Long Branch was home to the smallest park in the world. It was located on a 6-foot-by-2-foot spot. On May 30, 1899, a monument was erected to Dr. Thomas Chattle, the father of the Long Branch school system, by the Women's Christian Temperance Union. It was located at the intersection of Norwood Avenue and Broadway. In the form of a fountain, the monument was used for many years by thirsty horses stopping for a drink. It is now located on the grounds of city hall.

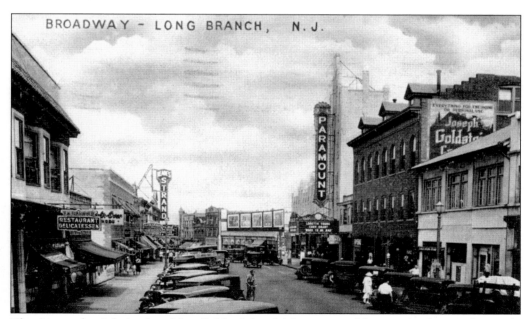

The sign on the right is advertising Goldstein's, which was one of the premier dry good stores in Long Branch. Located on the corner of Broadway and Liberty Street, it was known as Goldstein's Corner Store. It sold fabric, clothing, and shoes and offered credit with a handshake.

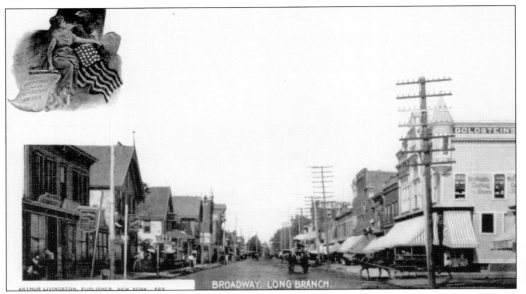

This is a typical day on Broadway.

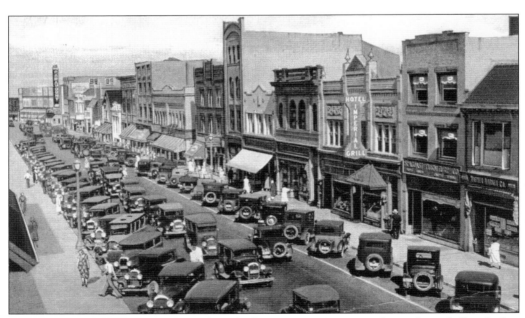

This postcard, dated 1934, is of Broadway looking east. Businesses and cars abound. Cars had to park on a slant to make room for the crowds that flocked to Broadway on a daily basis.

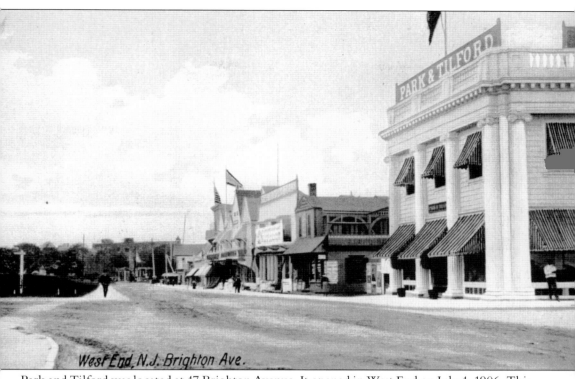

Park and Tilford was located at 47 Brighton Avenue. It opened in West End on July 4, 1906. This was an addition to its five exclusive stores in New York City that catered to the sophisticated tastes of its patrons. In the Long Branch store they maintained the same prestige by selling the finest provisions and imported delicacies to the city's summer visitors.

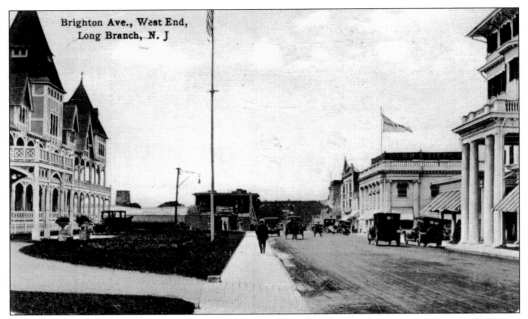

Brighton Ave., West End,
Long Branch, N. J

This postcard shows a street scene looking west on Brighton Avenue in West End. Many of the shop facades are still standing in the same grand style as they did at the beginning of the 20th century.

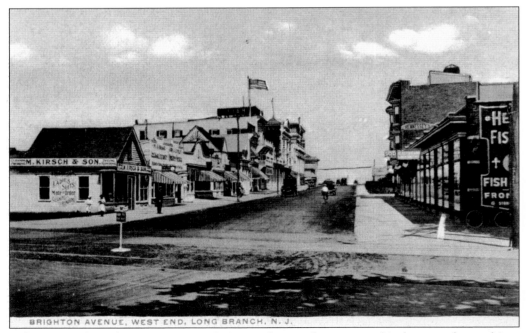

BRIGHTON AVENUE, WEST END, LONG BRANCH, N. J.

Fishing was a large business in town. Being so close to the ocean and its bounty, the catching, selling, and cooking of fish was an obvious way to make a living. Several fish markets lined Brighton Avenue when this undated photograph was taken.

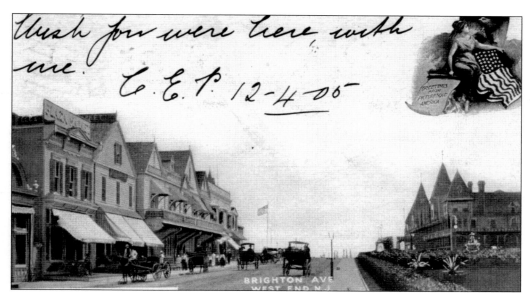

This image shows Brighton Avenue with an ocean view. The card is dated December 4, 1905. Phil Daly's Pennsylvania Club is on the right.

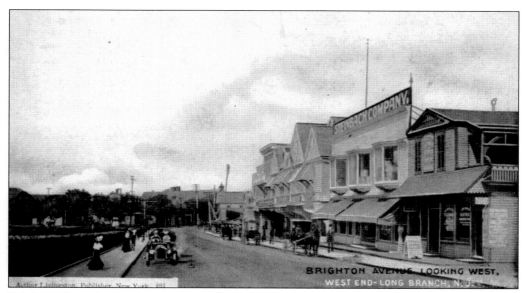

Brighton Avenue runs from Norwood Avenue on the west to the Ocean in the east. Lots of business and socializing took place on this street in the early 1900s.

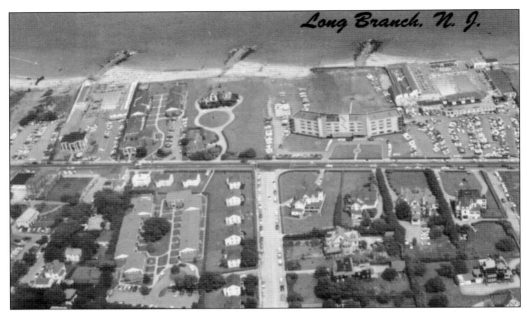

Cedar Avenue headed north comes right up to Ocean Avenue. This view from the air shows the oceanfront estates and a large hotel known as the Harbor Island Spa that were once located along Ocean Avenue on the east and west sides.

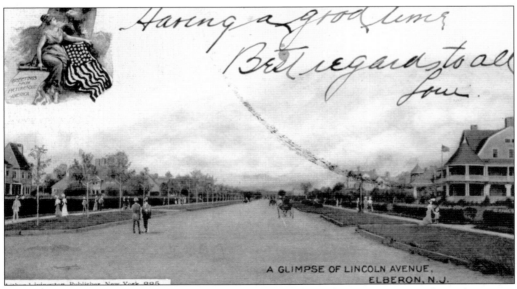

A GLIMPSE OF LINCOLN AVENUE, ELBERON, N.J.

This postcard shows Lincoln Avenue, a street that runs from the train station right to the ocean. It is the street on which Pres. James Garfield was carried by a temporary rail spur to the seaside cottage where he died in 1881.

This postcard shows the entrance to Elberon Avenue with a typical seaside cottage on the corner. Elberon Avenue runs from Park Avenue north to Lake Drive along Takanassee Lake.

Looking west, this postcard shows Park Avenue headed away from the ocean towards Norwood Avenue. At this time the entire street was taken up by what was known as the Woolley Farm. The bridge is going over the train tracks that run into the Elberon Train Station.

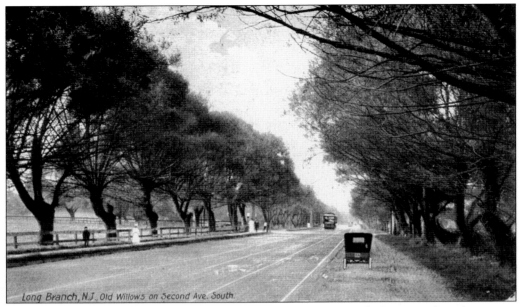

Second Avenue was one of the main thoroughfares in Long Branch. It was such an important street and so accessible to Broadway and other areas of town that trolley tracks ran along the street in 1909.

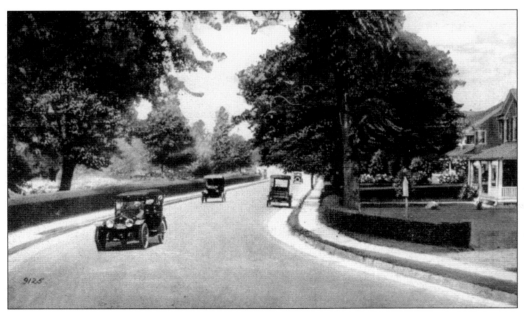

This view shows Norwood Avenue heading north towards Broadway. The pronounced curve in the road and some of the houses are recognizable today.

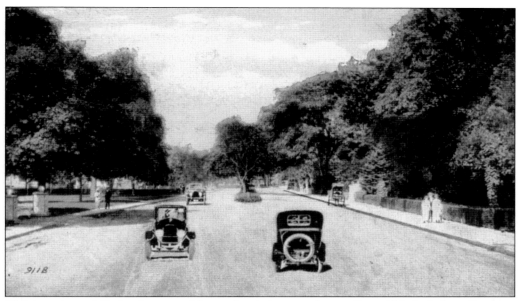

This is a view of Cedar Avenue with cars headed east and west. Beautiful shaded medians ran down the center of the road making it easy for pedestrians to cross from one side to the other.

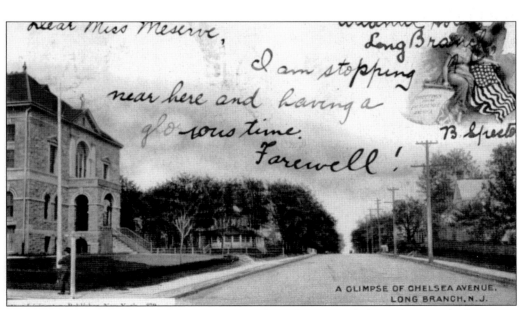

Named after a section in England known as Chelsea, this postcard shows the street looking east. The parochial school, Star of the Sea Lyceum, was on the corner of Third and Chelsea Avenues.

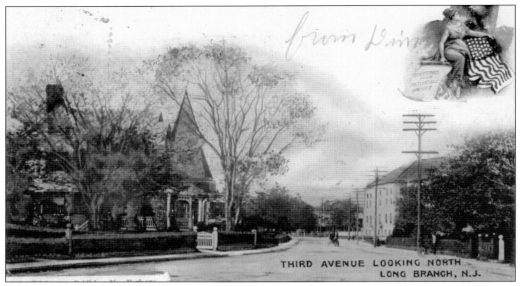

THIRD AVENUE LOOKING NORTH
LONG BRANCH, N.J.

Dated 1909, this postcard shows Third Avenue looking west toward Broadway.

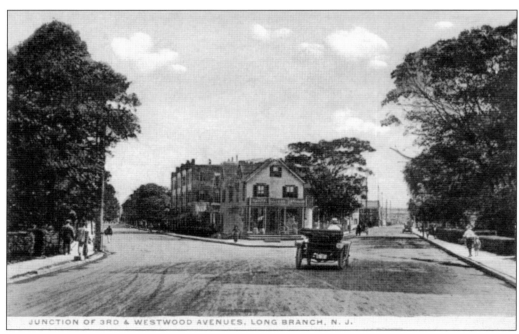

JUNCTION OF 3RD & WESTWOOD AVENUES, LONG BRANCH, N. J.

This is the intersection of Third and Westwood Avenues headed toward Broadway. A grocery store stands at the crossroads.

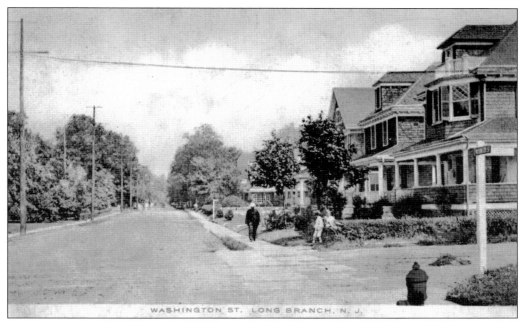

Washington Street was a typical residential street running north off Broadway. These were the homes of many of the Long Branch business owners and their families.

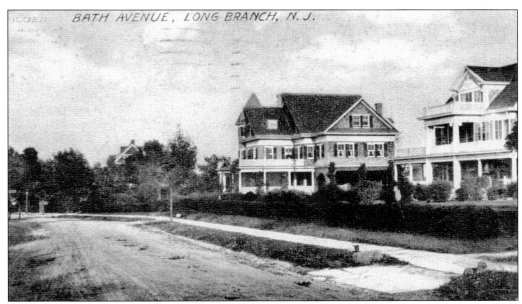

Bath Avenue was another of Long Branch's streets named after a section in western England. Dated 1911, this postcard shows the street looking west. Most of the grand homes are gone.

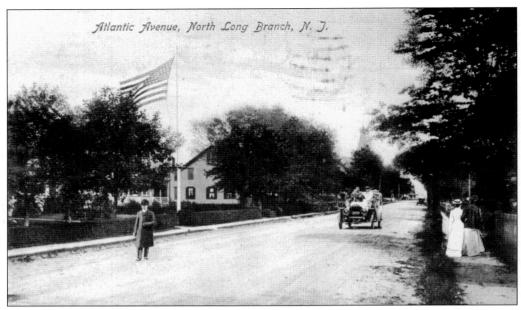

Atlantic Avenue was the main east to west thoroughfare in the North Long Branch section of town. Dated 1911, the note on the back reads, "Having a dandy time here in Long Branch."

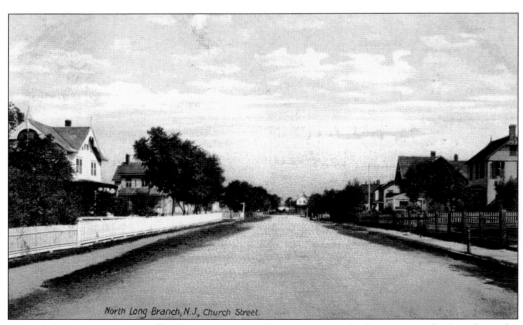

Church Street runs north off Atlantic Avenue. The Asbury Methodist Episcopal Church on the corner gave the street its name.

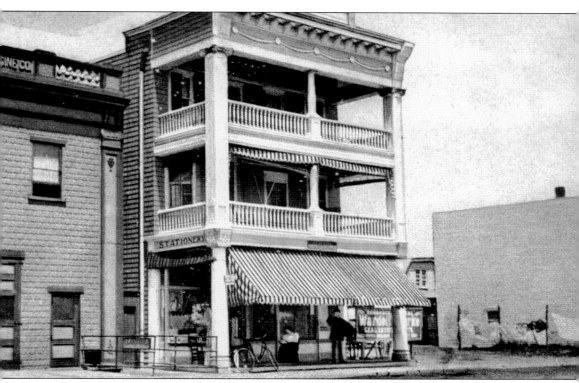

This area of town still looks exactly the same. It was known as the Stratton Block, named after J. A. Stratton, a strong proponent of the southern section of Long Branch known as Elberon. He promoted it as a pleasant place to live and do business.

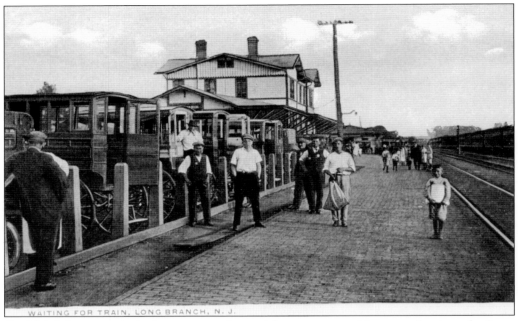

WAITING FOR TRAIN, LONG BRANCH, N. J.

On Third Avenue, cars and men are ready to pick up summer visitors coming into the Long Branch Train Station headed for the beach.

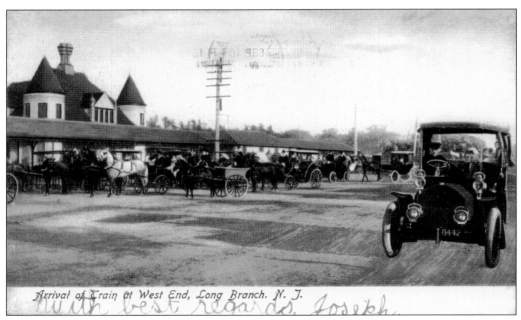

Arrival of Train at West End, Long Branch. N. J.

In 1906, there was a train station in West End to accommodate the wealthy summer residents traveling to New York on business. The chauffeur-driven car, on the lower right, was a usual sight.

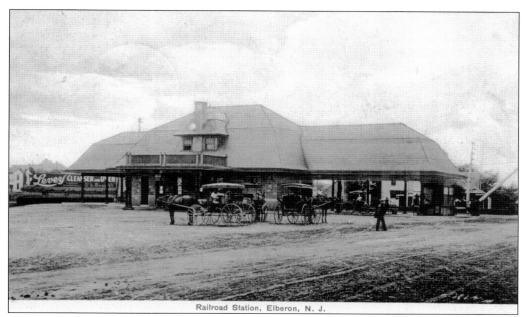

Railroad Station, Elberon, N. J.

The Elberon Train Station burnt in a fire in the 1980s. This was the train station Pres. James Garfield was brought to on his way to the Franklyn Cottage. He was taken there in 1881 in hopes that the sea air would speed his recovery after being shot by an assassin in Washington.

Uptown Broadway is pictured looking west in this postcard. This scene is at the corner of Branchport Avenue and Broadway. In 1872, the Long Branch Banking Company was organized as the first bank on the New Jersey coast. It was located in the upper village, also known as Uptown, at 577 Broadway. A bank with a more modern facade and different name is still located on this site. The building with the broken pediment is still on this spot.

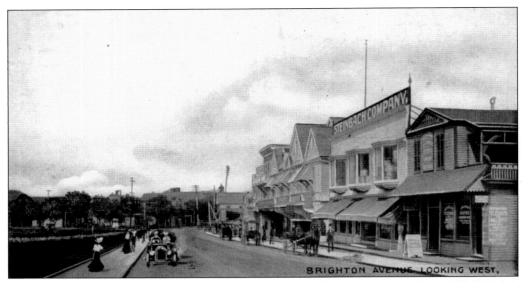

Looking west on Brighton Avenue there are shops on the right-hand side and Phil Daly's Pennsylvania Club is on the left. The West End Park is located there today.

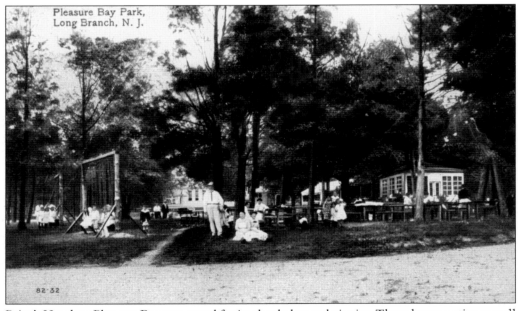

Price's Hotel on Pleasure Bay was noted for its clambakes and picnics. Three hours notice was all that was required to order a picnic that consisted of freshly caught clams, Jersey corn, potatoes, and chicken; all roasted under a seaweed tarp and served on wood plank tables set up along the shore of the Shrewsbury River, also known as Pleasure Bay.

Three

HOTELS AND HOUSES

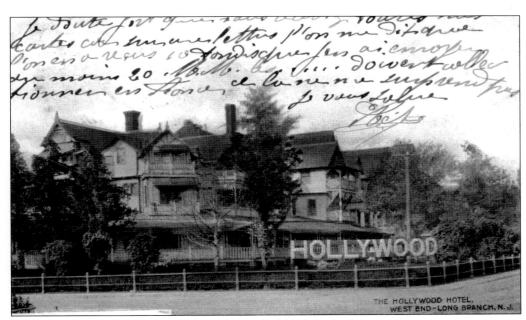

The Hollywood Hotel was located on the south side of Cedar Avenue.

The new Atlantic Hotel was located on Ocean Avenue in the West End section of Long Branch. It was destroyed in a spectacular fire during the height of the tourist season of 1925. This postcard was sent on June 28, 1925, just before the deadly blaze razed this structure.

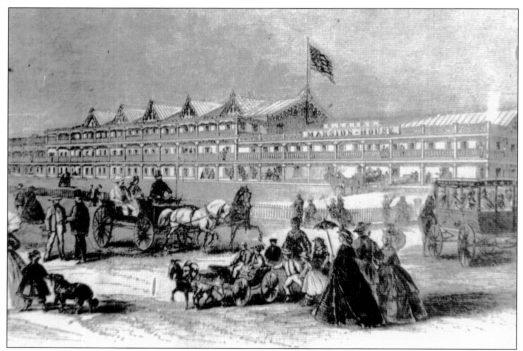

The Mansion House hotel was located on the northeast corner of Laird Street and Ocean Avenue. In 1861, when Mary Todd Lincoln, Abraham Lincoln's wife, was a guest here, the hotel was listed as Long Branch's finest. She stayed here for 10 days. During that time a grand ball and receptions were given in her honor.

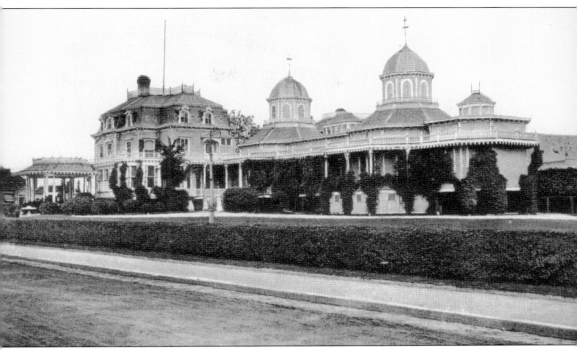

This postcard pictures Phil Daly's Pennsylvania Club as it appeared in the 1880s. It took up most of Brighton Avenue between Second and Ocean Avenues. It was the premier gambling house at the shore and attracted many high-rollers and politicians. Pres. Chester Arthur was a frequent visitor as was Pres. Ulysses S. Grant. When a Long Branch resident snuck in and lost heavily, Daly took him aside, returned his money and told him not to come back. The upper-crust was drawn to Long Branch and its many amenities, one of them being the Pennsylvania Club. Located on the southwest corner of the intersection of Brighton and Ocean Avenues, it was one of the most profitable gambling casinos on the east coast. An average season saw between $5 million and $10 million wagered. Women and local residents were not allowed entrance. To the south of the casino is the original Chamberlain Club House. Daly purchased this and expanded it to include the casino pictured above.

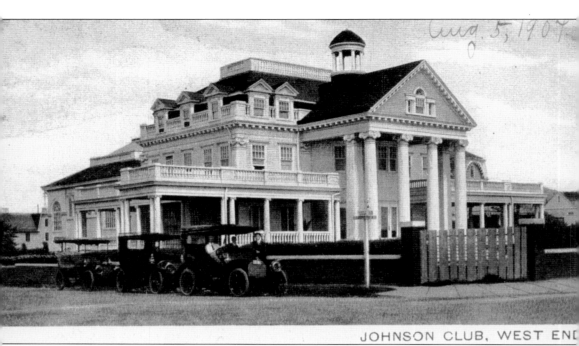

Aug. 5, 1907

JOHNSON CLUB, WEST EN[

This is an image of the Johnson Club. It was located next to Phil Daly's Pennsylvania Club on Ocean and Brighton Avenues. It was noted for its elegant dining and service. For many years it was managed by well-known restaurateurs from New York City. In 1910, it was enlarged and renamed the West End Shore Club.

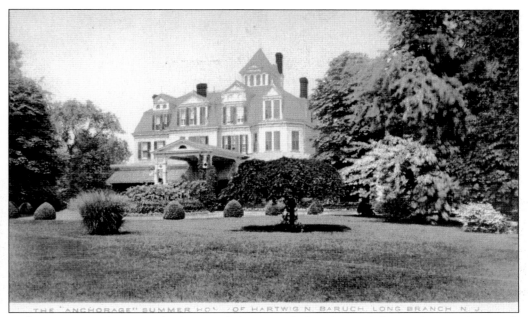

Welcome to Anchorage, the home of the Baruch family on Atlantic Avenue in North Long Branch.

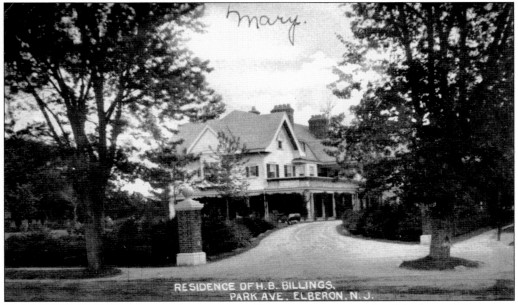

RESIDENCE OF H. B. BILLINGS,
PARK AVE., ELBERON, N. J.

This is the Billings home on Park Avenue in Elberon. It is an example of the beautiful summer cottages that lined the streets of town in the golden years of Long Branch.

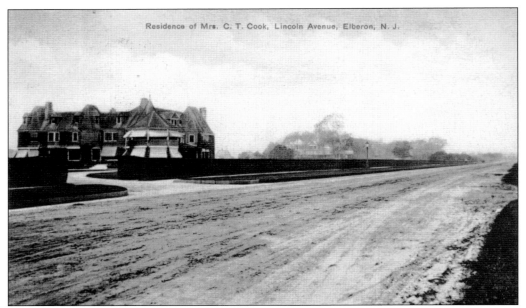

This is the Charles T. Cook residence, located on Lincoln Avenue in the Elberon section of Long Branch. The shingle-style home was designed by the renowned architectural firm of McKim, Mead and White in 1885. Cook was president of Tiffany and Company as well as best friends with the owner Charles Tiffany. Because the Cook and Tiffany families spent so much time together in the summer, the architect was asked to design a home that would comfortably accommodate two families. The house cost $33,000 to build.

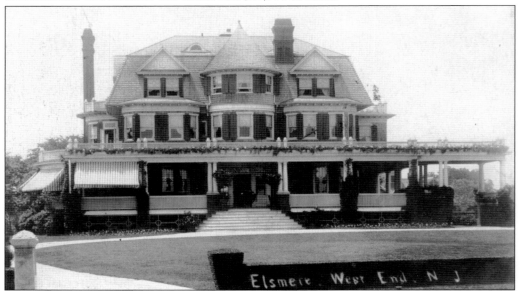

This is an example of some of the intricate architecture that came to be synonymous with the wealth and culture that were attracted to Long Branch at the beginning of the 20th century. This home, with its turrets and porches, was designed to take advantage of the cool ocean breezes. Named Elsmere, probably after the owner's daughter or wife, this beautiful home was located on Ocean Avenue in West End.

54

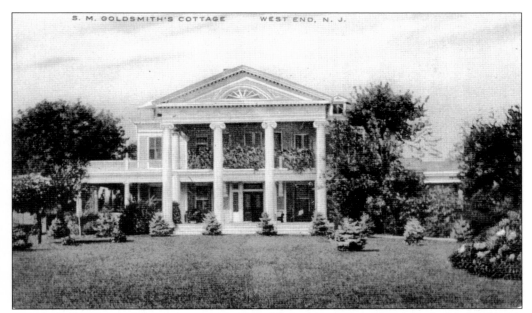

Although the postcard dated August 24, 1910, labels this photograph as the S. M. Goldsmith Cottage, the four pillars in front make it look more like a southern plantation house. This home is located on the west side of Elberon Avenue and today looks the same as it did nearly 100 years ago. Miss America Bess Myerson once lived here.

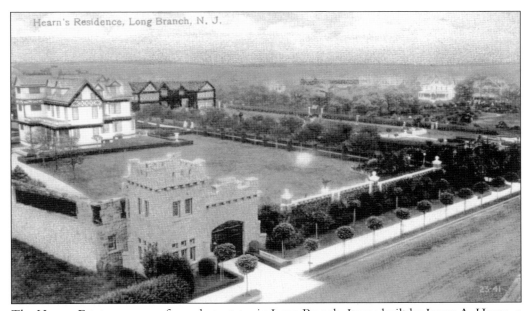

Hearn's Residence, Long Branch, N. J.

The Hearns Estate was one of grandest estates in Long Branch. It was built by James A. Hearn, a New York City art collector and department store owner. His English-style estate was built in 1888 on the southeast corner of Second and South Bath Avenues at a cost of more than $1 million. He housed many of his art treasures here. When he died his collection was donated to the Metropolitan Museum of Art. It is known as the James A. Hearn Collection.

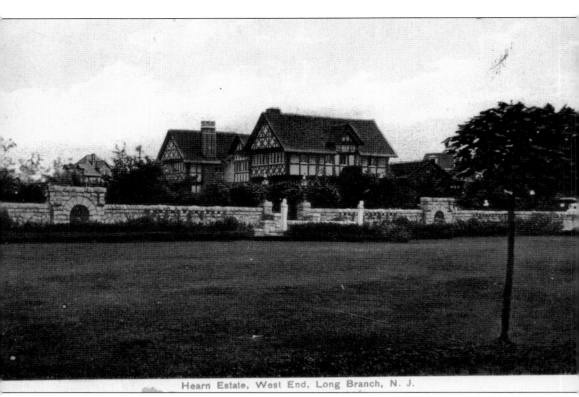

Hearn Estate, West End, Long Branch, N. J.

James Hearn loved to entertain at his seashore estate. He put his guests up in a house that was built on his grounds. It was an exact replica of Shakespeare's home at Stratford-on-Avon in England. The surrounding grounds were comprised of more than 300 rare trees, wide terraces, sunken gardens, and paths that were bordered with unusual shrubbery and intricate patterns of boxwood.

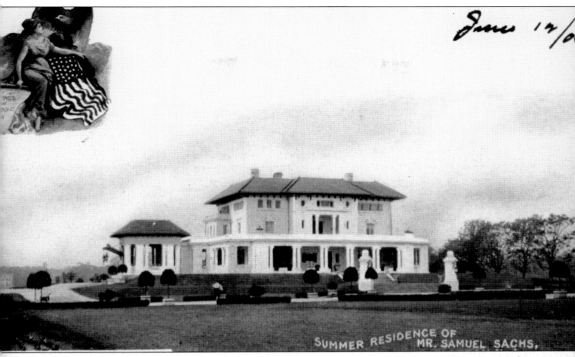

June 17/0

SUMMER RESIDENCE OF MR. SAMUEL SACHS,

Samuel Sachs, of Goldman Sachs Investment Firm fame, built a home on Ocean Avenue in the southern end of Elberon. It was white stucco with a red tile roof in the style of an Italian palazzo. The fountains and gardens were adapted from designs found in Versailles.

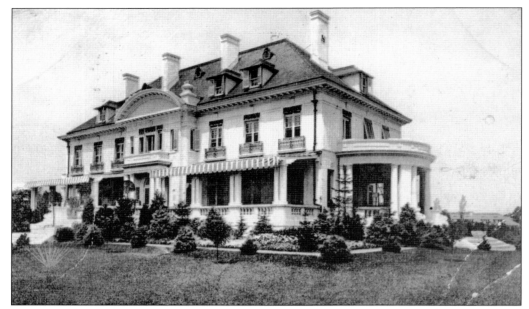

This postcard of the Stern Estate is dated 1913 and highlights a style of architecture that was popular in Long Branch. The stucco siding and tile roof keep the house cool in summer. The four chimneys indicate there were multiple fireplaces in the home to keep it warm during a summer storm. The windows and porches take advantage of the breezes. This home was owned by the Stern family and located on Ocean Avenue in the West End section of town.

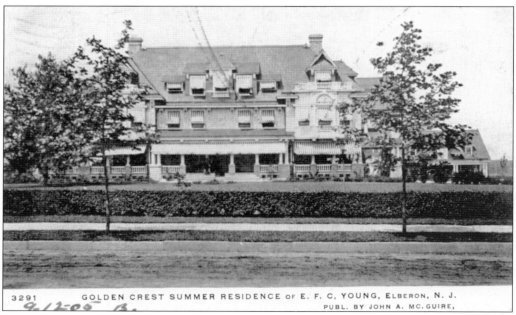

This sprawling home, Golden Crest, is pictured on a postcard dated 1905. In that year, the owner of the home was E. F. C. Young. Golden Crest was located on the west side of Norwood Avenue, just north of Park Avenue. It is still on this site and looks much as it did way back when.

58

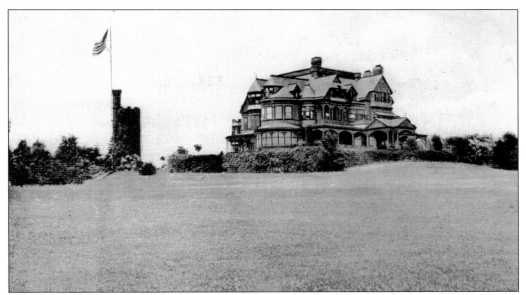

This grand home on Van Court Avenue was named Castlewall. It was built in 1881 by William Garrison. He died in a tragic railroad accident in Oceanport shortly after moving in.

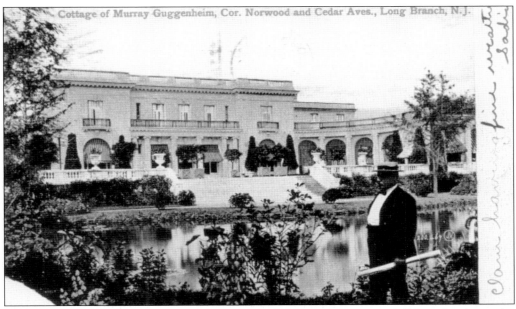

This was the home of Murray and Leona Guggenheim. Murray was one of three brothers who built estates in Long Branch. This home was designed by the architectural firm of Carrere and Hastings. They also designed the New York City Public Library and many other well-known buildings. This white marble home was an exact duplication of a Louis XVI palace. It is now the Guggenheim Library located at the corner of Cedar and Norwood Avenues, in the area known as West Long Branch.

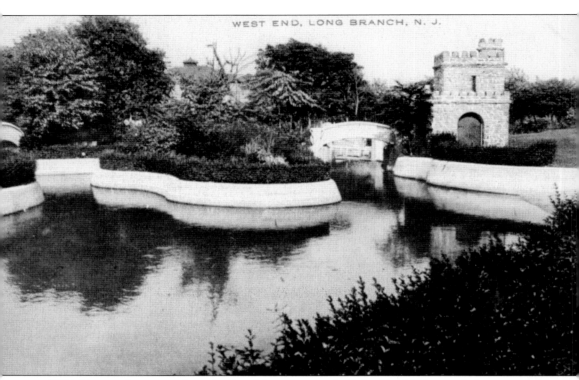

Il Diablo was the name given the Spanish-style estate built by Daniel Guggenheim, one of three Guggenheim brothers who built palatial homes in Long Branch. The millionaires made their fortune in the copper mining business and invested a great deal of it in local real estate.

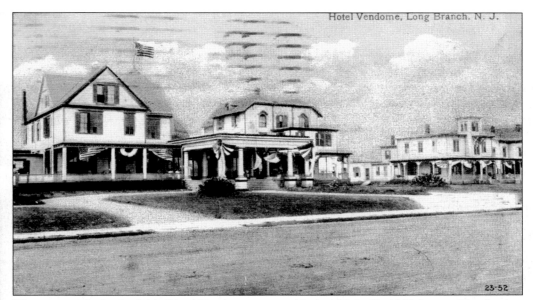

The note on the back of this Hotel Vendome postcard is dated July 10, 1915. It says, "Am having a quiet time here. Quite a crowd over the Fourth of July but now most are gone. Hopes for a good season. Regards, Marge." The bunting from the celebrations of the fourth is still hanging from the porches of the hotel.

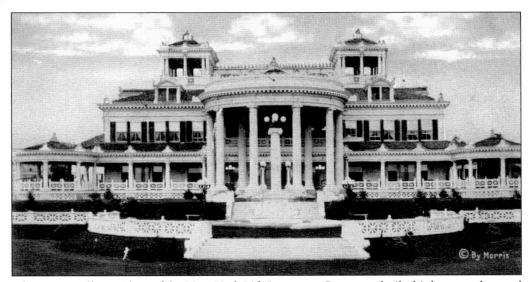

John L. McCall, president of the New York Life Insurance Company, built this home and named it Shadow Lawn. The three-story, white, wooden structure was located on 65 acres and took two years to build. With 52 rooms, it was completed in 1905. Pres. Woodrow Wilson used this residence during the summer he was seeking renomination from the Democratic party to run for a second term as president of the United States. During this time, Shadow Lawn became known as the Summer White House. Wilson accepted his party's renomination from the front porch in September 1916 and continued his campaign for reelection here. Shadow Lawn burned to the ground in 1927.

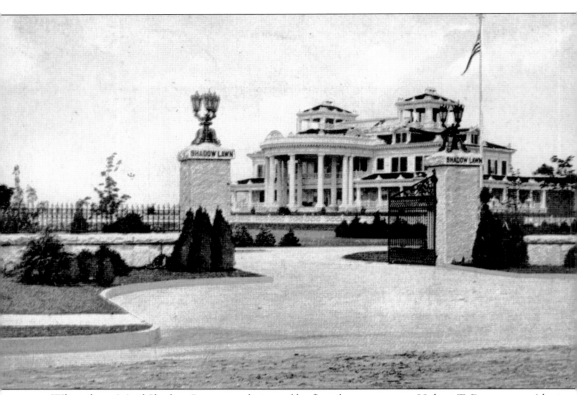

When the original Shadow Lawn was destroyed by fire, the new owner, Hubert T. Parsons, president of W.F. Woolworth Company, made plans to rebuild it. On the site he erected a Italian-style marble mansion. It had 128 rooms that included a theater, bowling alley, an indoor swimming pool, and terraced gardens on the roof. Parsons ran into some financial trouble and eventually lost the house to foreclosure. The home, now called Wilson Hall, houses the administrative offices for Monmouth University and is located on Cedar Avenue in West Long Branch.

Located at 991 Ocean Avenue, this was the summer home of Pres. Ulysses S. Grant from 1869 to 1884. It was purchased and presented to his family by four millionaires from Elberon who were his friends and confidants during and after the Civil War.

John Hoey, president of the Adams Express Company, built the Hollywood Hotel in 1882 in keeping with the popular style of the time. Hotels were built to resemble private estates with a large main building and beautiful grounds. His hotel was called the Hollywood because of the groves of holly trees that surrounded the property. Guests came primarily to see the magnificent gardens. The gardens at Hoey's Hollywood were considered one of the grand sights in America.

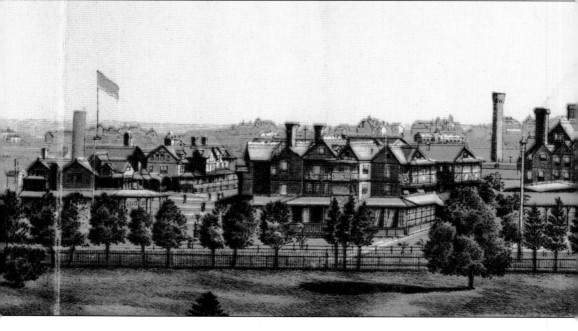

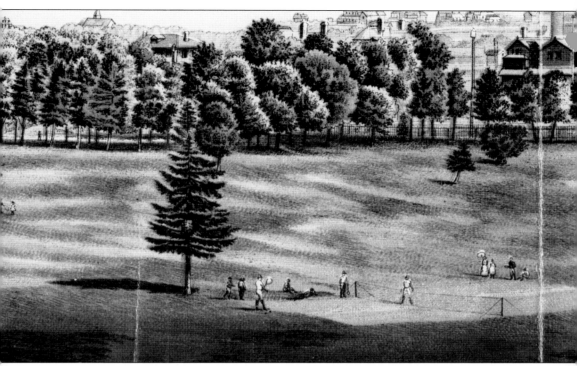

A massive 650-feet-long greenhouse contained rare and exotic tropical plants. Tree-lined drives wound past brooks, summer houses, and vast expanses of flower beds. Takanassee Lake was included in this tract that ran south from Cedar Avenue. A green lawn of 20 acres swept to the south from the front porch of his home. More than 50 gardeners were employed to keep this park in peak condition.

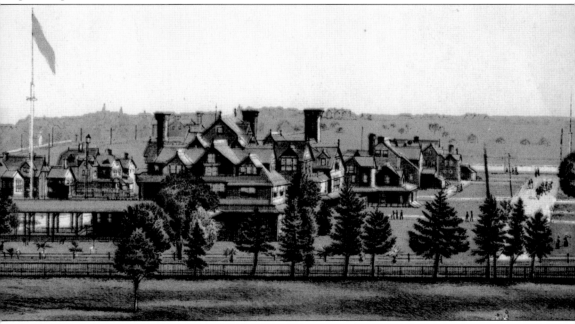

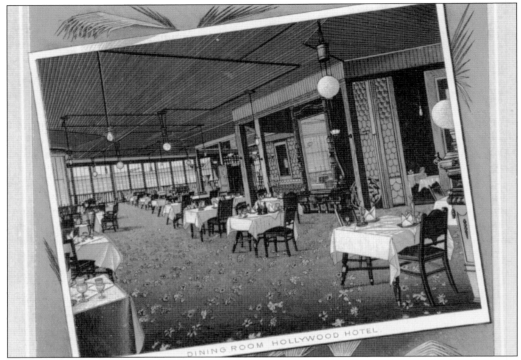

This was the dining room of the Hollywood Hotel. Many grand occasions took place here.

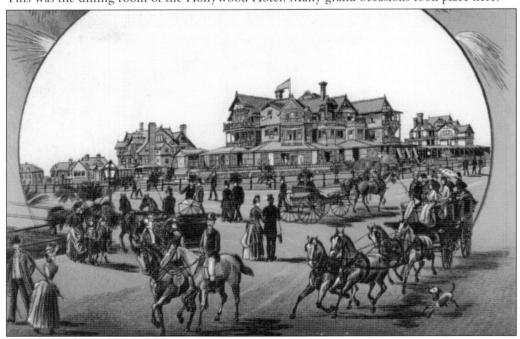

On Cedar Avenue, visitors are arriving at the Hollywood Hotel in their finest attire and well turned-out carriages. Pres. Ulysses S. Grant often stopped here for a slice of huckleberry pie and a swig of whiskey.

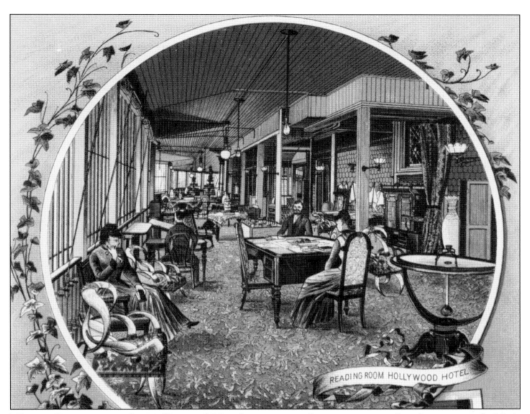

The reading room at the Hollywood Hotel was meant for guests to read and correspond. Most of the best hotels at this time provided a room like this for guests who wanted to keep up with their friends and business associates while on vacation.

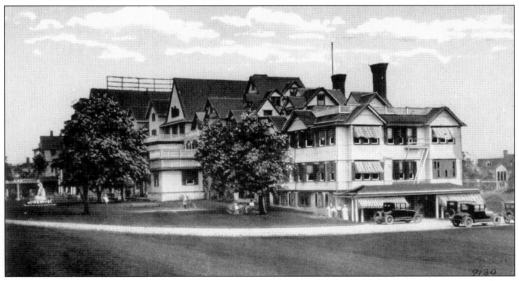

This is a view from the side of the Hollywood Hotel showing the garages that were ready to store the newest craze, the automobile.

The statue of an armless Greek goddess stands in front of the Hollywood Hotel. This statue originally stood at the entrance to John Hoey's 650-foot-long triple greenhouse. It was just one of many statues that adorned Hoey's 250-acre estate.

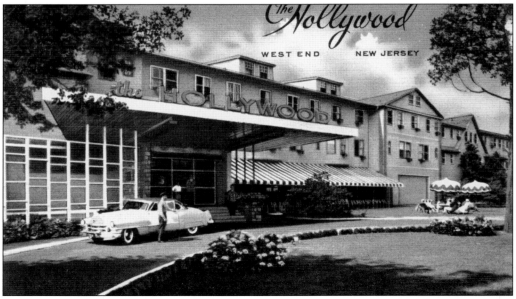

By the 1950s, the Hollywood had evolved into a modern day hotel. The old wood building was fronted by a gleaming new sign and the driveway was often filled with the two-toned convertibles that were all the rage. In the 1960s, the hotel burned in a fire that took several days to extinguish.

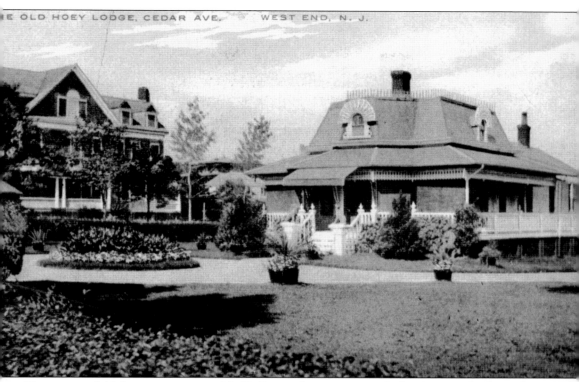

E OLD HOEY LODGE, CEDAR AVE, WEST END, N. J.

Hoey erected 13 large cottages on his Hollywood property on Cedar Avenue. Built in the wooden Eastlake design, they were open to accommodate those wishing to visit the Jersey Shore in the winter.

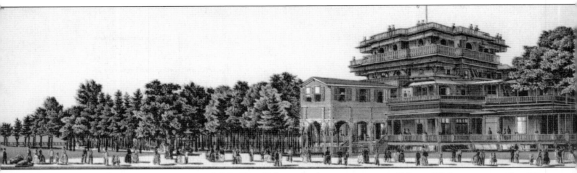

In 1879, John Hoey converted his English–style house to resemble a Chinese pagoda. Hoey designed and supervised the construction of this home. The wooden fretwork was made from the lumber of the abandoned Grand Excursion House from the Philadelphia uxposition.

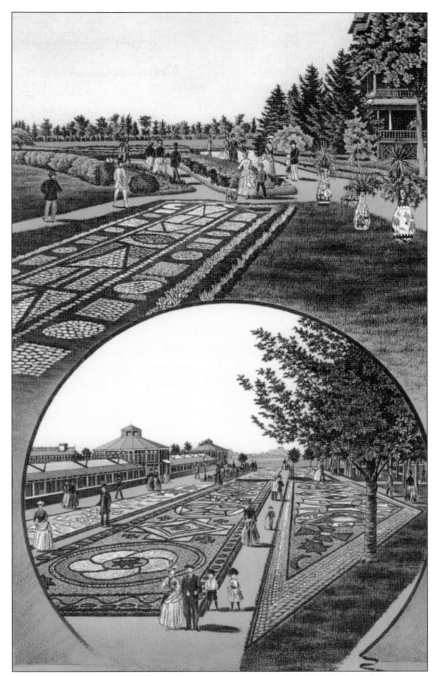

The grounds of the Hollywood Hotel offered guests a beautiful park and a golf course. However, the most spectacular sight on these grounds were the gardens that were made to look like oriental rugs, inspired by the more than 50 Italian gardeners Hoey employed. Hoey and his gardeners grew flower carpets that measured 80 feet by 40 feet, reproducing Daghustan and Teheran rug patterns using green and red foliage. From the hotel porches stretched a beautiful view of carpets made of flowers.

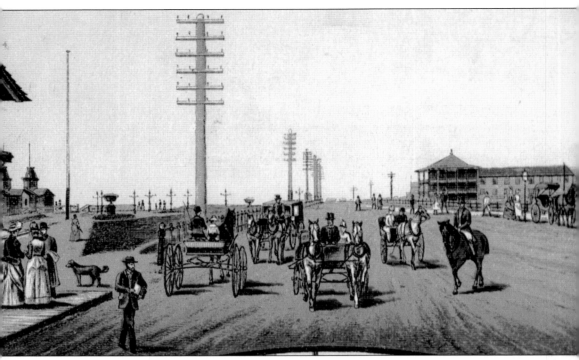

Leland's Ocean Hotel in 1873 was located on the southwest corner of Ocean Avenue and Broadway. The dining room was 50 by 200 feet and could seat 650 people easily. The weekly

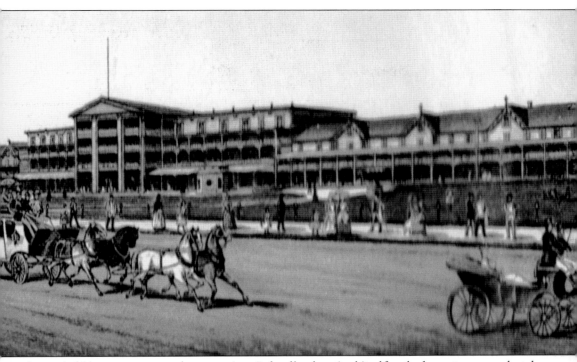

dances held here were a popular attraction. Leland's advertised itself as the largest summer hotel in the world. It is now the site of the Ocean Place Conference Center.

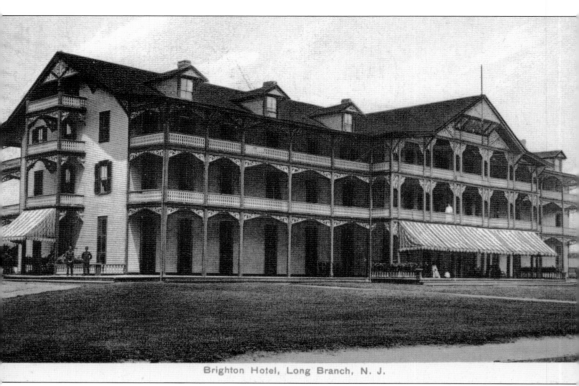

Brighton Hotel, Long Branch, N. J.

The Brighton Hotel replaced the Metropolitan Hotel that was destroyed by fire in 1876. The Brighton Hotel stood on the northwest corner of Cooper and Ocean Avenues. This hotel burned in 1932. The Promonade Beach Club is the newest replacement.

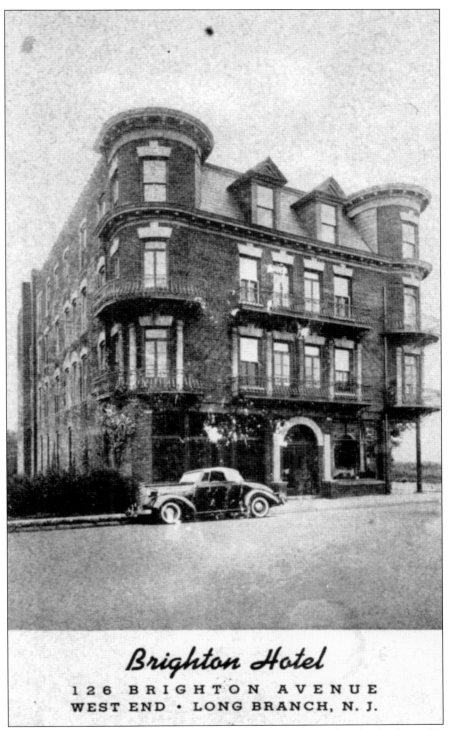

Brighton Hotel

126 BRIGHTON AVENUE
WEST END · LONG BRANCH, N. J.

Many things in Long Branch were named Brighton, including this hotel, which was located at 126 Brighton Avenue in West End.

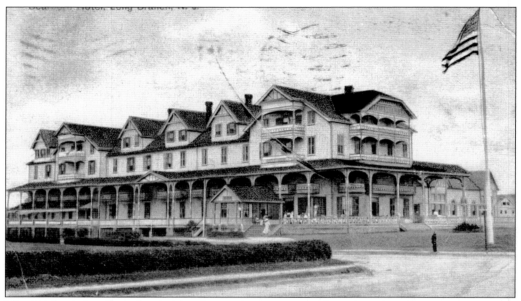

The Scarboro hotel was located on the northwest corner of South Bath and Ocean Avenues. It was originally made of clapboard, which was eventually replaced by stucco and tile. The note on the back of this postcard dated June 1908 reads, "This is the hotel in Long Branch, New Jersey that we are painting." The salt air and sea winds took a toll on many of the wooden structures along the ocean.

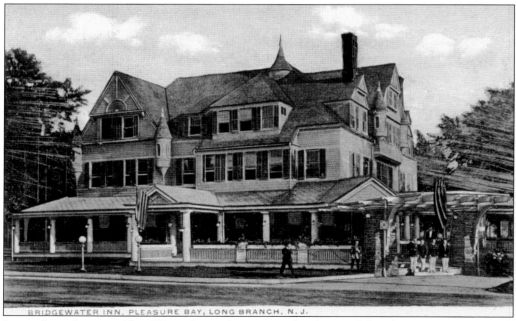

BRIDGEWATER INN, PLEASURE BAY, LONG BRANCH, N. J.

Located on the west side of Branchport Avenue on the shores of the Shrewsbury River, this building has had many names throughout the years but has always remained a place to enjoy the hospitality Long Branch has to offer. The exterior has changed a bit, and it is now a Mexican restaurant known as Casa Comida.

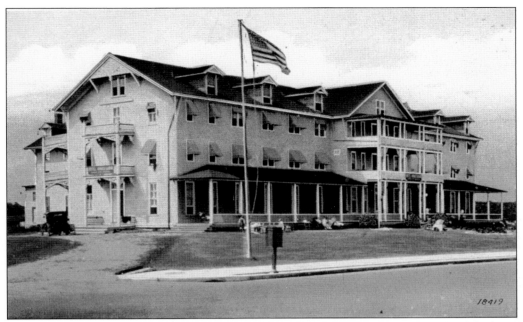

Welcome to the Ambassador Hotel. This undated postcard shows another example of the large hotels that were so prominent along the oceanfront. Most hotels offered the European plan, which included a room and three meals a day at a reasonable price.

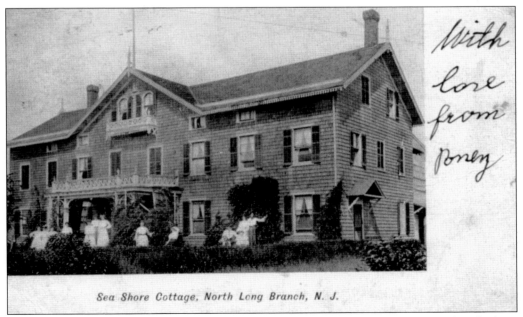

Sea Shore Cottage, North Long Branch, N. J.

This is the Sea Shore Cottage in North Long Branch. More modest than the larger hotels along the ocean, many Long Branch residents rented-out rooms in their homes during the summer months. Weekly room and board was affordable and the family atmosphere comfortable. These were the forerunners of today's bed-and-breakfast inns.

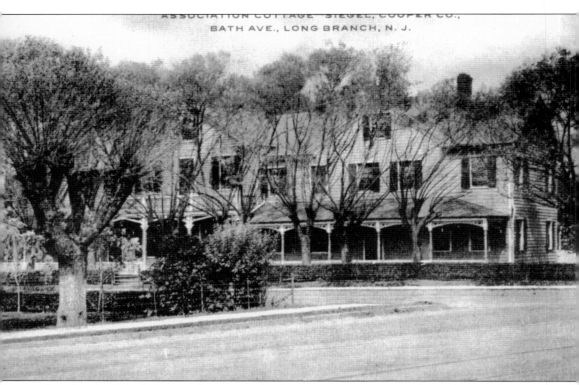

ASSOCIATION COTTAGE SIEGEL, COOPER CO.,
BATH AVE., LONG BRANCH, N. J.

Run by the Seigel Cooper Company, the Association Cottage was located on Bath Avenue. This could have been the place where workers from this company were housed while working away from home.

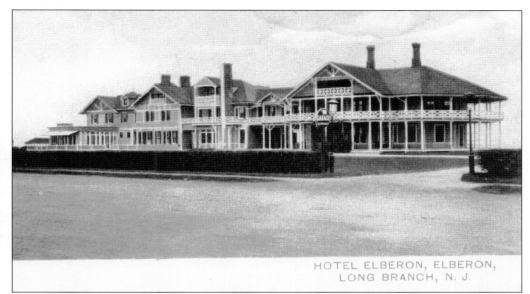

HOTEL ELBERON, ELBERON,
LONG BRANCH, N. J.

In the late 1800s, the Elberon Hotel was the newest and smartest of the shore hotels. It was located on the ocean, just south of Pres. Ulysses S. Grant's summer cottage. It was designed by the famous New York City architectural firm of McKim, Mead and White. Built to resemble a rambling English hunting lodge, compared to other hotels in town it was a rustic sight. The Elberon Hotel was used as the communication center while Pres. James Garfield was a patient at the adjacent Franklyn Cottage in 1881.

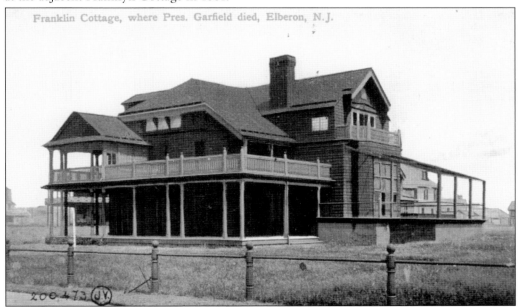

Franklin Cottage, where Pres. Garfield died, Elberon, N.J.

The Franklyn Cottage was owned by Charles Franklyn, president of the Cunard Shipping Lines. When Garfield was shot in Washington, D.C., in 1881 he was brought to this seaside cottage to recuperate. He died there on September 20, 1881. The home is no longer there, but a plaque commemorates the historic two weeks he spent at this spot. The site is at the end of Garfield Avenue in Elberon.

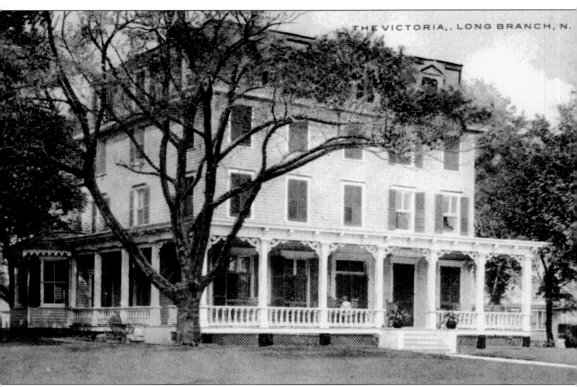

Seen here is the Hotel Victoria. Located on Second Avenue, this hotel was preferred by quiet family groups summering in Long Branch. This hotel was a block west of the more-crowded Ocean Avenue.

Four

PUBLIC BUILDINGS

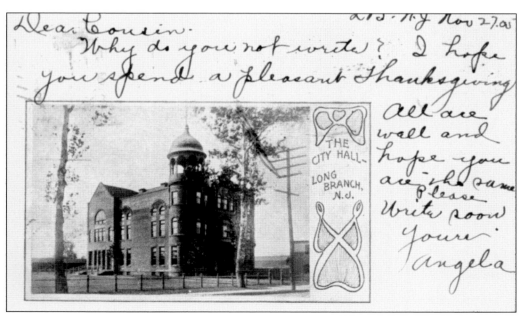

The original city hall, located on Broadway, was erected in 1891.

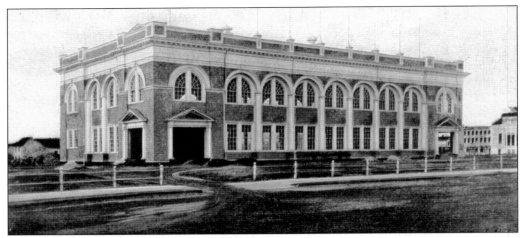

This building was used for many civic purposes including encampments for the training of soldiers. The old Casino Annex was used as a Red Cross workroom and in 1919, became a recreational center for injured soldiers. It was also used for the training of regiments in preparation for the war. See the note below.

This note was signed Papa and written to a daughter telling her that this is the building in which his regiment was training.

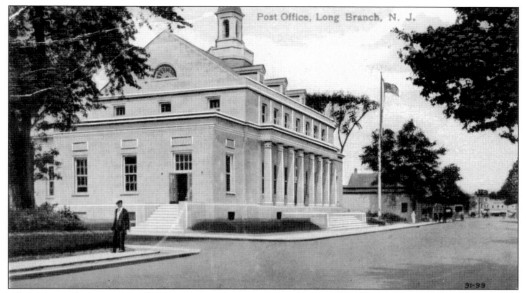

The original Long Branch Village Post Office was established May 28, 1834, and designated as private by the department in Washington, D.C. This meant that mail was carried there by private individuals from the nearest public post office.

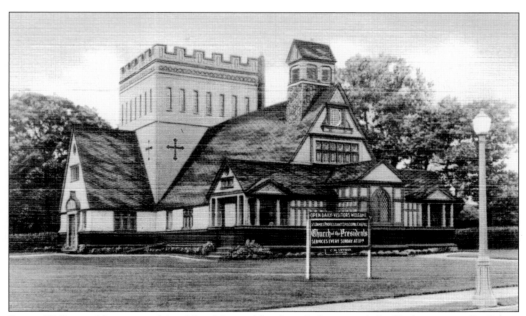

Seven U.S. presidents worshiped in this seaside chapel. It was originally known as St. James Chapel. Located on Ocean Avenue, south of Lincoln Avenue, Presidents Garfield, Grant, Arthur, Hayes, Wilson, McKinley, and Harrison all attended services here during their respective terms. While Pres. James Garfield was a patient across the street at the Franklyn Cottage, the bells of the church tolled regularly in hopes of his recovery.

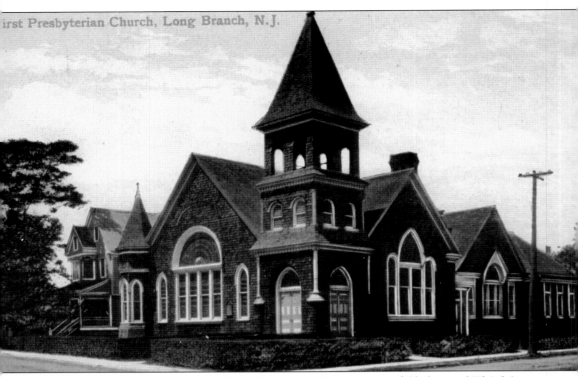

The First Presbyterian Church is located at the southeast corner of Chelsea and Third Avenues. It was dedicated on March 16, 1894. Through the years it has weathered shingles with white trim and Georgian moldings with long wide gables. The church is now sided in gray and is known as the Salem Baptist Church.

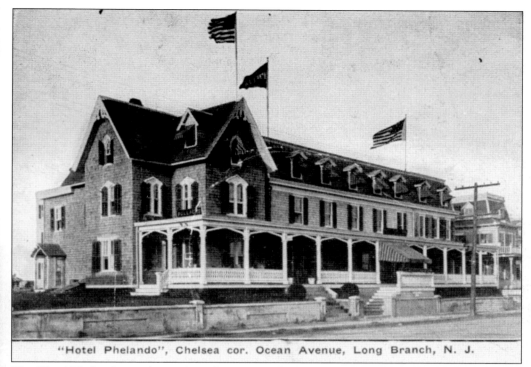

"Hotel Phelando", Chelsea cor. Ocean Avenue, Long Branch, N. J.

The Hotel Phalendo was located on the corner of Chelsea and Ocean Avenues. The Victorian style is also echoed in the modern-day buildings that now make up Pier Village.

The administrative building of Monmouth University was once the lavish home of Hubert T. Parsons and his wife. In 1981, the movie *Annie* was filmed here.

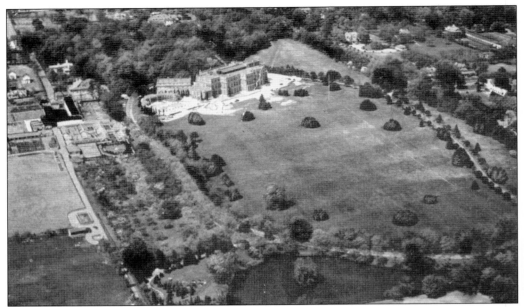

This aerial view of Monmouth University gives an idea of its naturally beautiful campus. The university is located on the corner of Cedar and Norwood Avenues in what is now called West Long Branch.

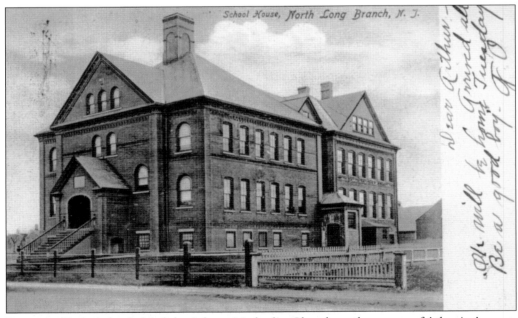

Because of its location behind the Asbury Methodist Church on the corner of Atlantic Avenue, this grade school was named Church Street School. It was erected in 1891, in response to a campaign to bring better education to the children of the city. The building stands unoccupied on the same site.

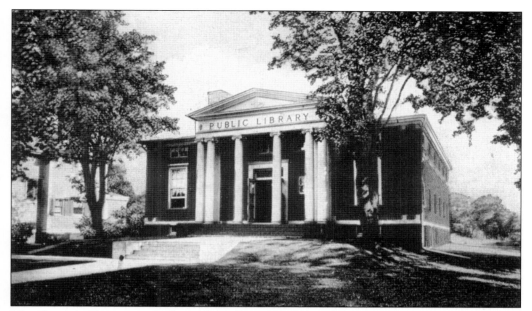

The Carnegie library was the last to be endowed by the Andrew Carnegie Corporation. With a $30,000 grant in 1920, the city was able to build the one-story redbrick building on Broadway.

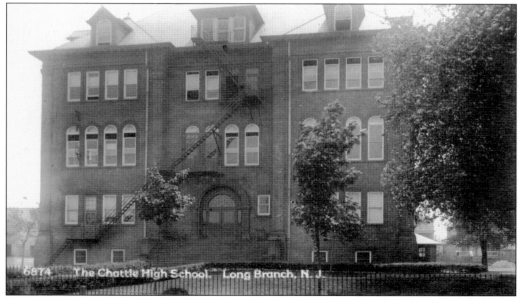

Named for Dr. Thomas Chattle, the father of public education in Long Branch, this secondary school was built on Morris Avenue at a cost of $78,000.

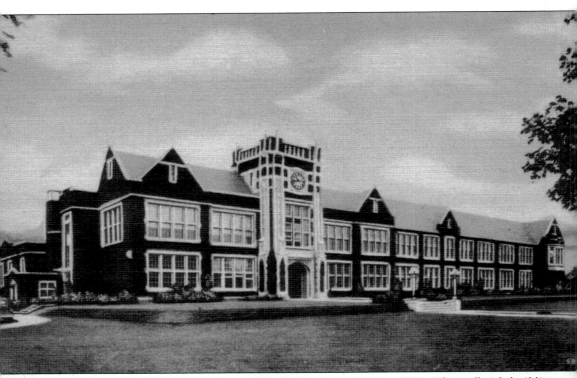

The cornerstone of the Long Branch High School was laid in 1926. The redbrick building, with simplified white classic decorations, was built at a cost of $683,000 and officially opened in 1927. It is located on Westwood Avenue in Elberon.

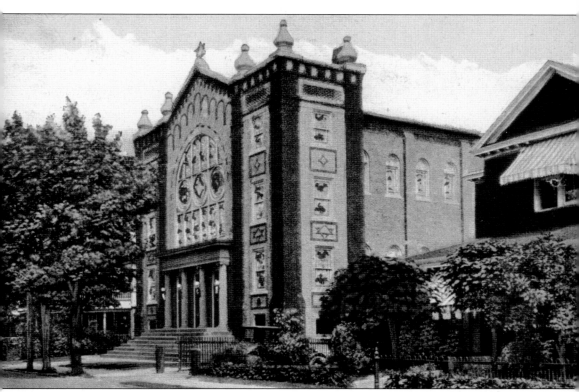

This synagogue was originally located on Second Avenue. The new Congregation Sons of Israel is now located in a modern building on Park Avenue.

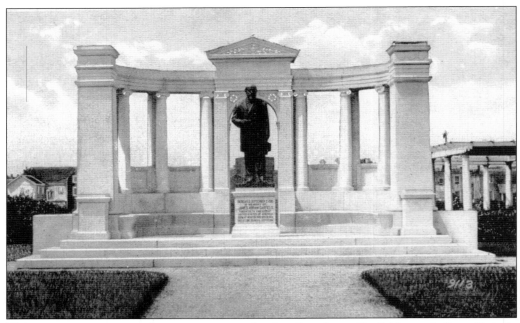

This monument was erected to commemorate the time Pres. James Garfield spent in Long Branch. From September 6 to September 20, 1881, Garfield was in Long Branch to take advantage of the sea air in hopes that he would recover from an assassin's bullet. He died on September 20, 1881. This monument is located on the boardwalk.

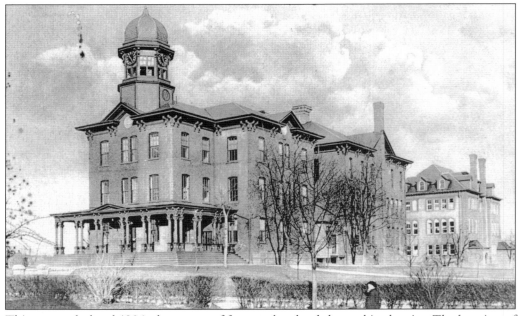

This postcard, dated 1906, shows one of four grade schools located in the city. The location of this school was Broadway and Academy Alley, the latter named for its academic association.

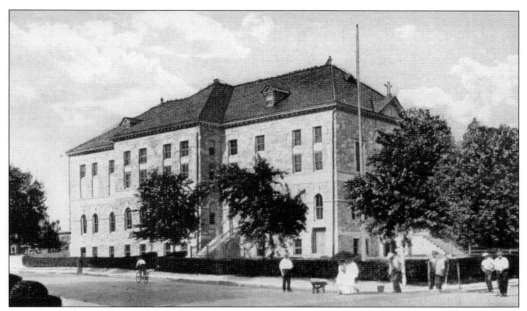

Located on the corner of Third and Chelsea Avenues, this parochial grammar school, Star of the Sea Lyceum, offered free tuition to local students.

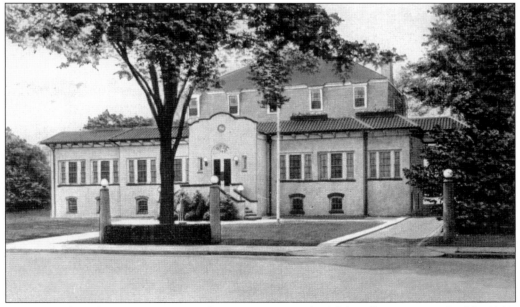

Long Branch Lodge No. 742, Benevolent Protective Order of the Elks, was organized in 1901. In 1908, the old Garfield Hotel at 150 Garfield Avenue was taken over, redecorated, and opened. It is still at this location and serves many charitable organizations.

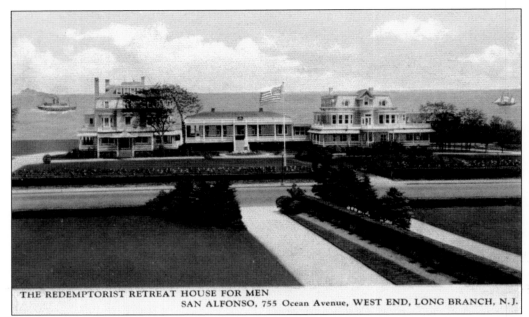

THE REDEMPTORIST RETREAT HOUSE FOR MEN
SAN ALFONSO, 755 Ocean Avenue, WEST END, LONG BRANCH, N.J.

This was the original wooden retreat complex that served an order of Catholic priests. The restful location on the ocean provided the perfect atmosphere for prayer and contemplation. This building was replaced by the present brick structure known as San Alphonso Retreat House located on Ocean Avenue.

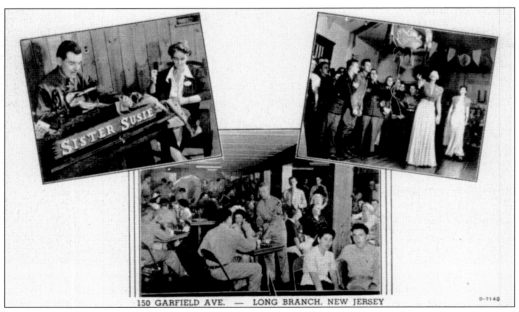

150 GARFIELD AVE. — LONG BRANCH, NEW JERSEY

The USO Club served as a place for soldiers to be entertained during World War II. It operated out of the Elks Lodge on Garfield Avenue and called itself, "A Home Away From Home."

Five

BESIDE THE SEA

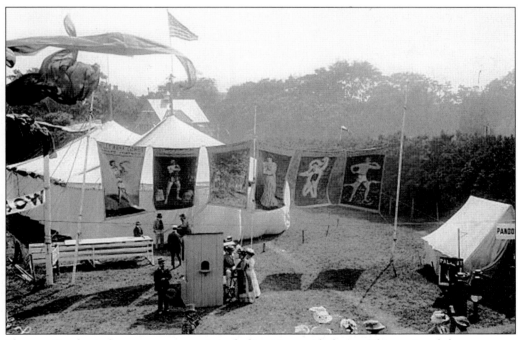

Pleasure Bay hosted many amusements including circus sideshows. This postcard shows groups of people lining up to purchase tickets to the events that included shooting galleries, balloon ascensions, and games. In 1904, crowds lined up to see Mrs. Murphy go up in a balloon on Saturday at 2:00 p.m. Everyone was disappointed when Mrs. Murphy turned out to be a monkey trained to parachute out of the balloon's basket.

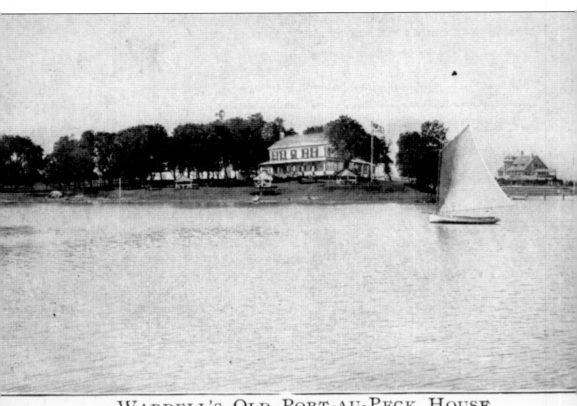

WARDELL'S OLD PORT-AU-PECK HOUSE

Wardell's Port-Au-Peck Hotel was located opposite Pleasure Bay and named for one of the original Long Branch settlers, Eliakim Wardell. Located on the banks of the Shrewsbury River, it was a destination for the Patten Line Steamboats as well as visitors waiting to be served a classic shore clambake that consisted of local clams, Jersey corn, and chicken all steamed in a bed of seaweed.

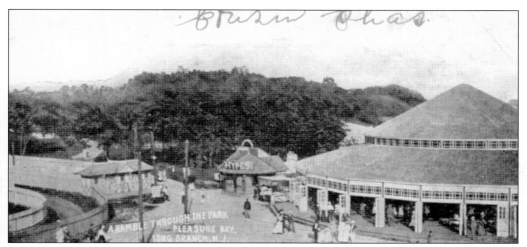

Seen here is another view of the Pleasure Bay amusement area on the shores of the Shrewsbury River.

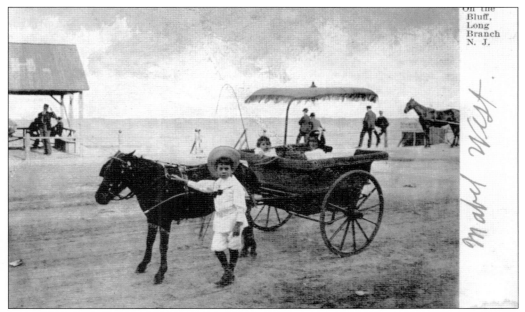

Many of the wealthier residents of Long Branch presented their children with pony or goat carts.

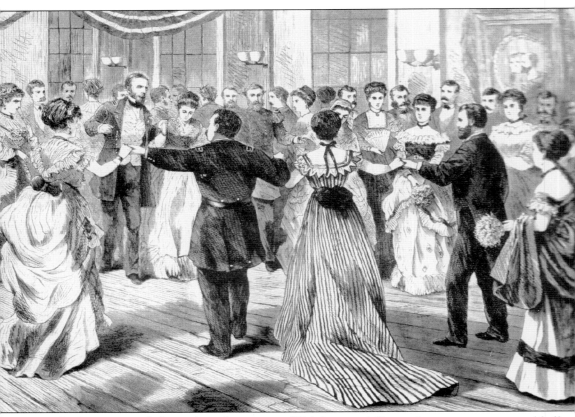

The Stetson Hotel, located on the corner of Brighton and Ocean Avenues, gave a grand ball for Pres. Ulysses S. Grant in the summer of 1869. Not one for dancing, Grant commented to a hopeful partner, "Madam, I would rather storm a hill than have another dance." In 1883, the Stetson Hotel was renamed the West End Hotel.

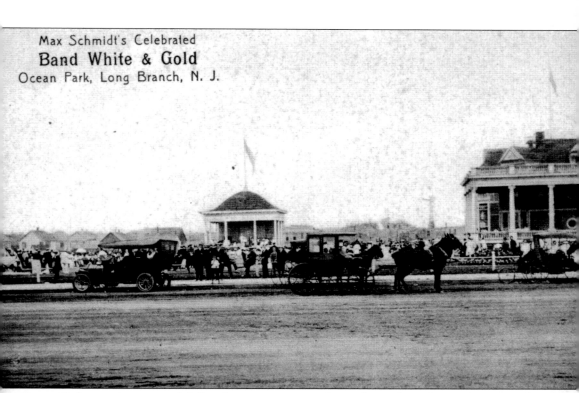

Max Schmidt's Celebrated
Band White & Gold
Ocean Park, Long Branch, N. J.

Ocean Park was the scene of daily afternoon concerts. It was located on Ocean Avenue and prided itself on its 10 acres of parks, flower beds, and fountains.

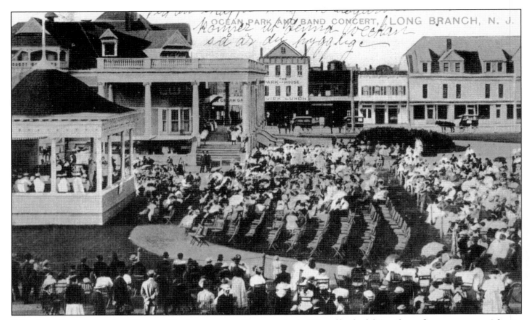

The band concerts at Ocean Park were well attended. Usually held in the afternoon, residents and vacationers dressed in their best when attending.

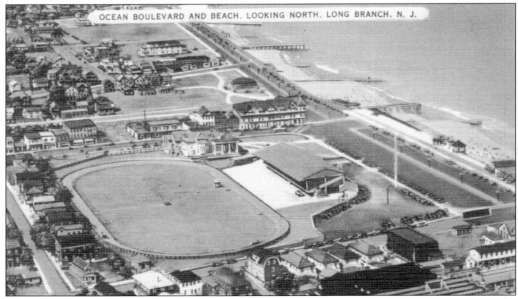

Cornelius Vanderveer built a circular racetrack on his estate at the northwest corner of Joline Avenue and Liberty Street. Later known as Wheeler's Trotting Park, it sponsored small events. In 1866, a horse race offered a $25 prize to the winner.

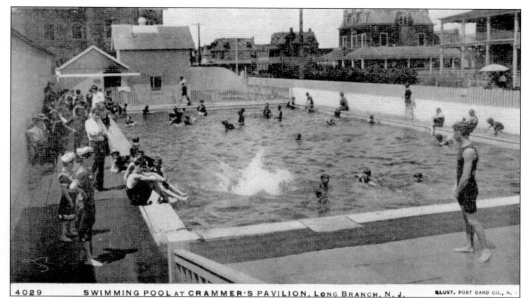

A popular swimming spot, Cranmers Pavilion was located on the west side of the boardwalk. There was an underground tunnel attaching the pool and lockers with the beach.

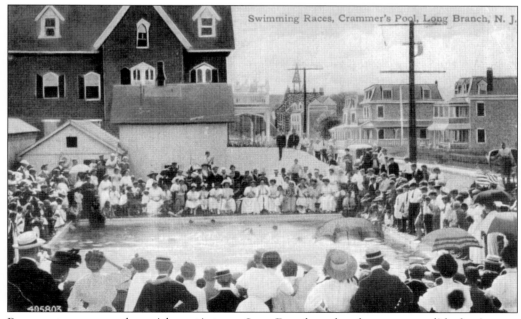

Race meets were a regular social event in town. Long Branch produced many accomplished swimmers and noted lifeguards. Frank Sinatra was a lifeguard in Long Branch. He met his first wife, Nancy, here while lifeguarding. She lived on Nesto Terrace, a street close to the boardwalk.

Carnival, Long Branch, N. J.

In the early 1900s, parades were very popular. Baby parades were an institution in town for many years. There were so many children born in one area of town, Fourth Avenue, it was renamed Baby Lane. In 1905, the first baby parade was organized. It was so successful that three years later it was renamed the Children's Parade, with more than 1,000 participants. The parade route ran from the corner of Ocean and Brighton Avenues along the boardwalk to Broadway. The parade was disbanded because it was felt the heat and excitement of the event were harmful to the children.

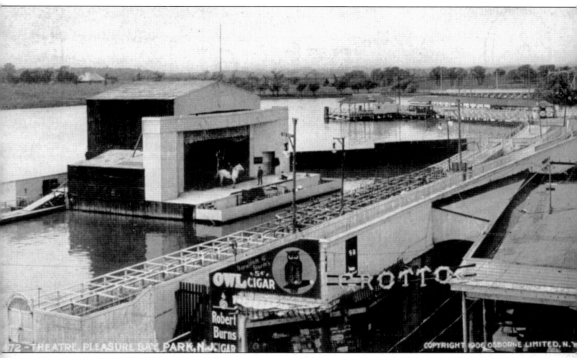

A floating stage on the Shrewsbury River was one of the centerpieces of Pleasure Bay. Audiences of as many as 2,000 watched performances of Gilbert and Sullivan operettas and other musical and dramatic productions. The actress Charlotte Greenwood broke into vaudeville on the Pleasure Bay Stage. In 1938, Greenwood recalled, "People in rowboats smacked up against the stage all through our act. We were on right after Fink's Mules."

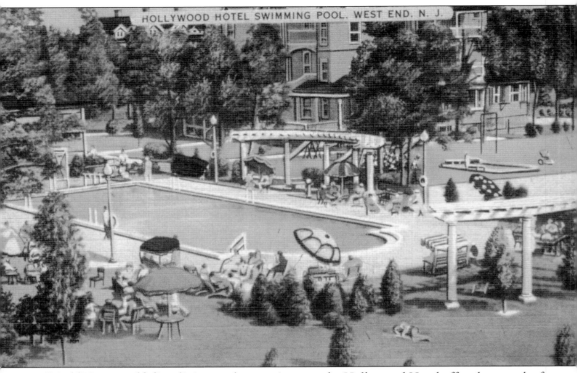

HOLLYWOOD HOTEL SWIMMING POOL, WEST END. N. J.

In addition to golf, fine dining, and entertainment, the Hollywood Hotel offered guests the fun of taking a dip in its inground pool or to sunbathe on a cushioned lounge. This was a typical scene on the grounds of the hotel througout its hayday. The main building was destroyed by fire.

Six

PRETTY PLACES

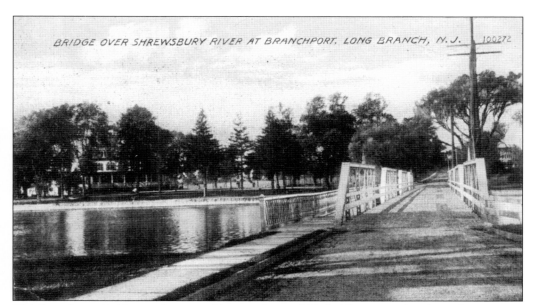

The Branchport Bridge ran between Pleasure Bay and Little Silver over the Shrewsbury River. In 1894, the bridge was powered by a coal fired steam engine.

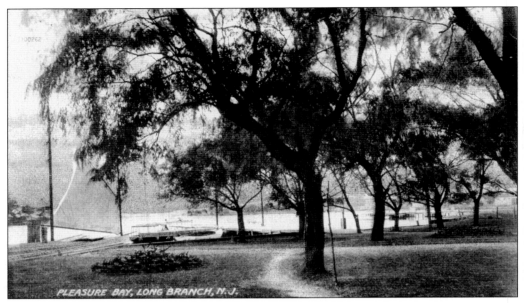

This is a picture of the banks of Pleasure Bay on a beautiful day.

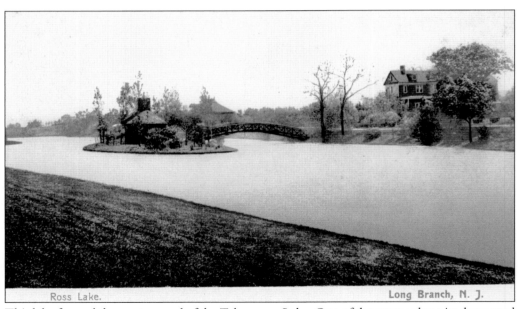

This lake formed the western end of the Takanassee Lake. One of the estates along its shore used a small island on the lake for leisure activities. Ross Lake is located on the east side of Norwood Avenue opposite Monmouth University.

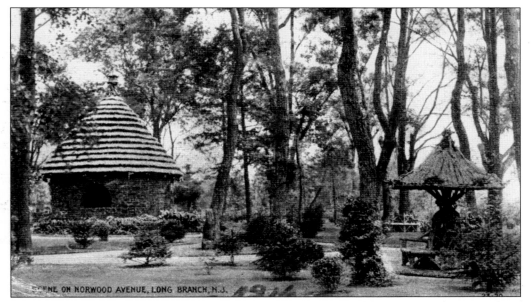

This stone teahouse, once part of the Parson's Estate, can still be seen on the grounds of Monmouth University.

Dated September 7, 1916, this postcard, written by an actor, says, "I am playing in 'Civilization' at the Broadway Theater."

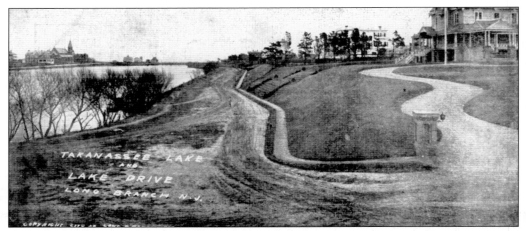

This is a driveway leading to one of the many mansions lining Lake Shore Drive along Takanassee Lake.

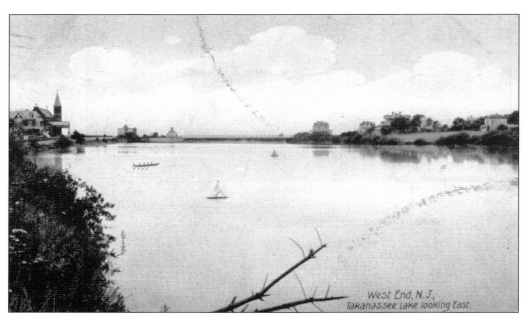

This postcard is dated 1924. The Lake Takanassee Bridge is in the background along with the now demolished home of Edgar Dinkelspeil. The New Jersey Life-Saving Station is in the upper left-hand corner. There three original buildings still stand at this spot.

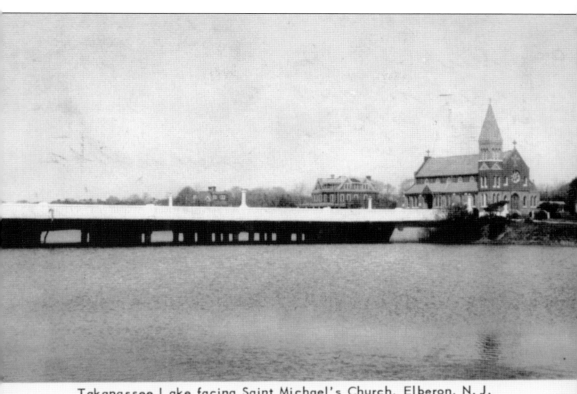

Takanassee Lake facing Saint Michael's Church, Elberon, N. J.

This is what the view from the ocean is like looking west over Takanassee Lake and bridge. St. Michael's Church is on the upper right-hand side.

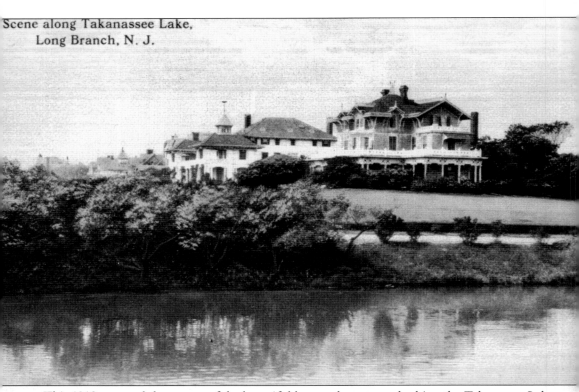

Scene along Takanassee Lake,
Long Branch, N. J.

This 1912 postcard shows one of the beautiful homes that sat overlooking the Takanassee Lake on the southwest corner of Ocean Avenue.

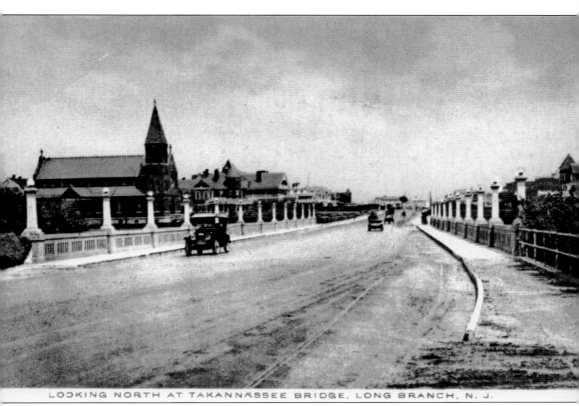

LOOKING NORTH AT TAKANNASSEE BRIDGE, LONG BRANCH, N. J.

Dated 1909, the writer of this postcard was staying at 22 Cooper Avenue in Long Branch. She writes to her aunt, "Charlie and I enjoy our machine so much. This is one of our favorite rides across the bridge. The ocean is on the other side."

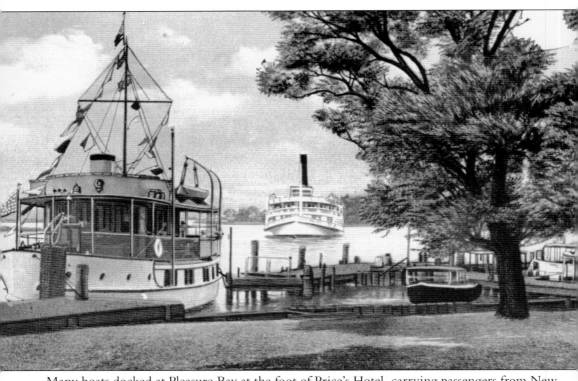

Many boats docked at Pleasure Bay at the foot of Price's Hotel, carrying passengers from New York for a day at the shore.

Seven

IMPORTANT PEOPLE

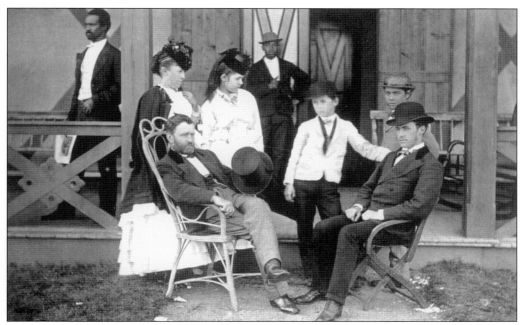

The Grant family enjoyed their days at the Jersey Shore. They are shown here relaxing on the front porch of their seaside cottage on Ocean Avenue.

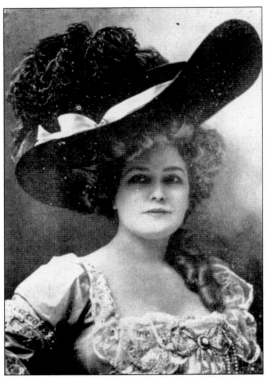

The beautiful actress Lillian Russell was known as the first pin-up girl as well as the girlfriend of "Diamond Jim" Brady. It was said that the diamonds he often wore were dimmed when he entered a room with Russell on his arm. Russell had a summer home on Bath Avenue.

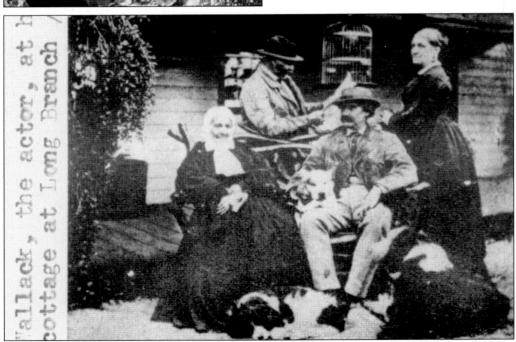

This image shows the Wallack family in a restful scene at their home in Long Branch. John Lester Wallack was a member of the famous acting family and owner of Wallack's Theater in New York City.

Annie Brown came to Long Branch from Ireland in the late 1860s. She was fortunate to find employment as a domestic in Pres. Ulysses S. Grant's summer cottage on Ocean Avenue. The home she built at 264 West End Avenue is still there. Her granddaughter Dorothy Williams still lives in Long Branch as do many of her great- and great-great-grandchildren.

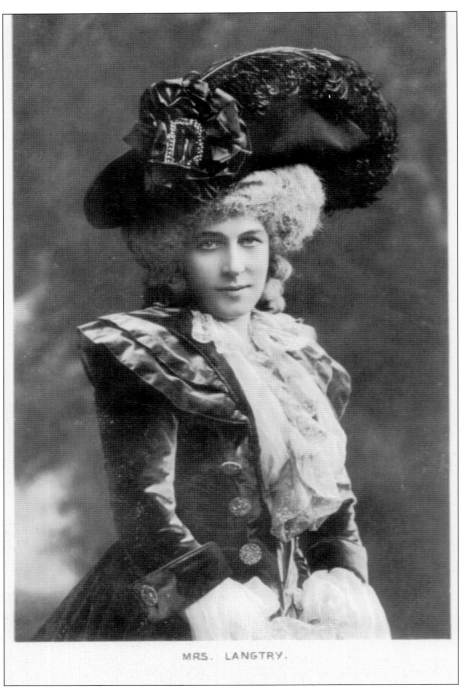

MRS. LANGTRY.

Lily Langtry was one of the many theatrical personalities that performed as well as vacationed in Long Branch. She often stayed at the northeast corner of Second and Chelsea Avenues in one of the ornate cottages built by gambling casino owner Phil Daly. The name of the cottage was the Catherine, named after Daly's wife. During the summers, while Langtry stayed with the Dalys, she parked her private Pullman railroad car on a railroad siding off of Bath Avenue.

Eight

SERVING OTHERS

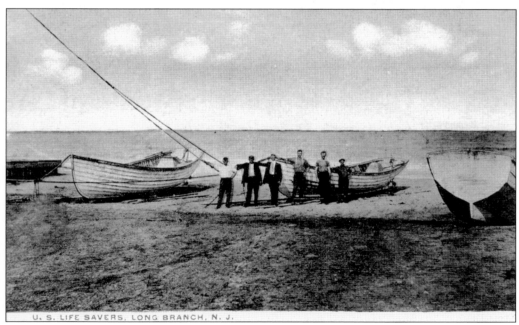

U. S. LIFE SAVERS, LONG BRANCH, N. J.

These six men, members of the United States Life-Saving Service, are ready for the next shipwreck or emergency. Between 1831 and 1853, Long Branch lifesavers participated in the rescue of nine ships in distress.

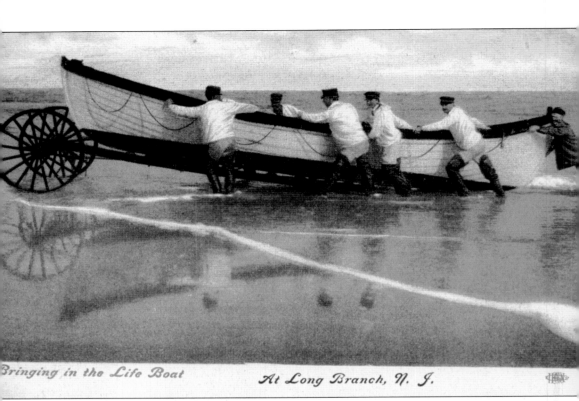

Bringing in the Life Boat *At Long Branch, N. J.*

Resting on a small catapult, this lifesaving boat is being eased onto shore by five lifesavers and one helper.

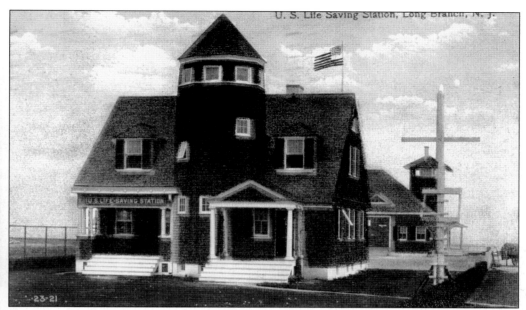

Dated 1913, this is one of the original United States Life-Saving stations located in Long Branch.

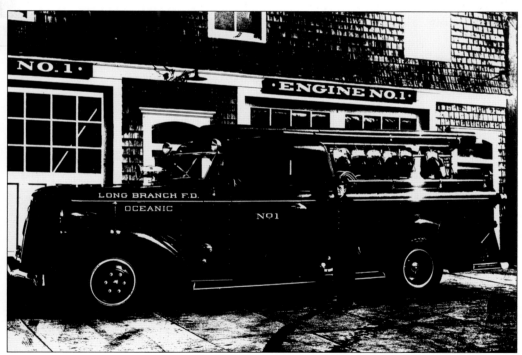

The Oceanic Fire Company No. 1 is Long Branch's oldest volunteer fire company. In 1869, the Oceanic Firehouse on Norwood Avenue was built to house two pieces of equipment, a steam fire engine to pump water from cisterns and a hook and ladder fire truck. One of the Miller brothers from Long Branch is pictured in front of the wood-sided Oceanic Firehouse in this undated photograph.

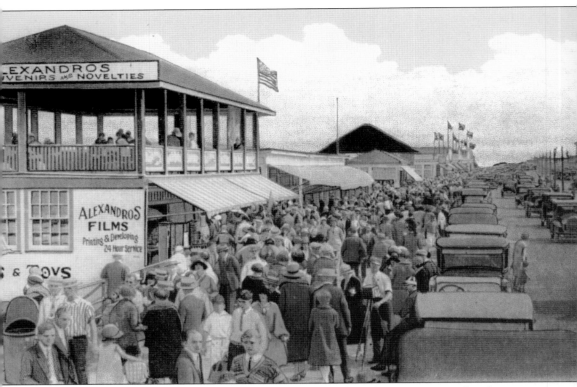

The boardwalk is the place to be in Long Branch. In the early 1900s, it was the place everyone went for a relaxing stroll, to enjoy the cool breezes, the beautiful view, and the variety of stores, shops, and entertainment that abounded. Automobiles brought crowds from allover to this spot on the shore.

Nine

BUSINESS

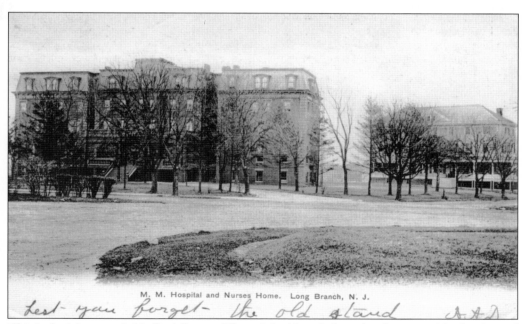

M. M. Hospital and Nurses Home, Long Branch, N. J.

Lest you forget— the old stand

This is the Monmouth Medical Center. The original hospital was headquartered in the Central Hotel, located on Third Avenue across from the railroad station. In 1887, it was known as the Long Branch Hospital and later as Monmouth Memorial. Through the years, two additions were made to the Central Hotel building, which included hospital rooms and a nurses' residence. This was the humble beginning of the now nationally-recognized medical center.

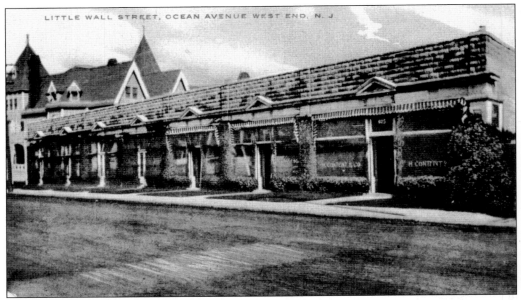

These buildings adjoining the Rothenberg Hotel on the southwest corner of West End Court and Ocean Avenue made up an area of West End known as Little Wall Street. Because there were so many New York City investors summering in Long Branch, a branch of the New York Stock Exchange was opened in the hotel.

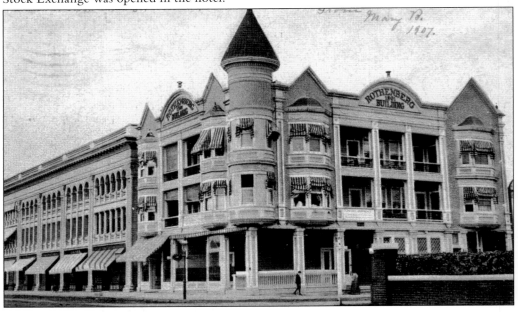

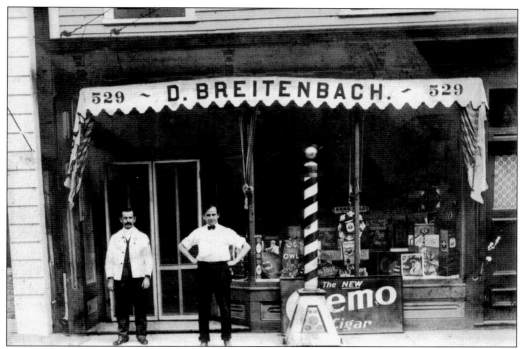

This family-owned barbershop was one of the many businesses that ran up and down Broadway. The business was located at 529 Broadway and was owned by Dionis Breitenbach (right). Standing on Breitenbach's right side is Fred Tram.

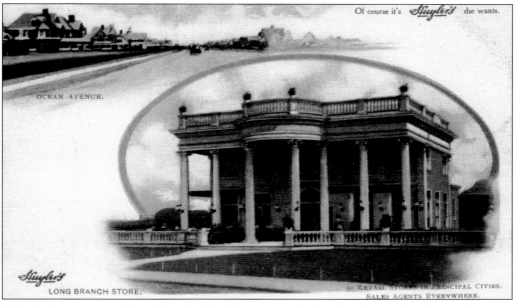

Only the best comes to Long Branch. Huyler's was a confection shop located on Ocean Avenue in West End. In order to suite the tastes of the selective New Yorkers summering in Long Branch, many shops opened branches here. Huyler's was one of them, selling ice cream, bonbons, fine chocolate, and ice-cold soda water.

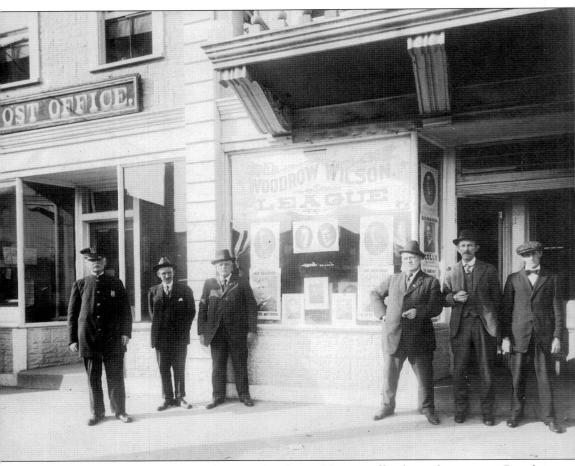

These Long Branch residents are pictured in front of the post office located on uptown Broadway. The year is 1916 and Woodrow Wilson is running for president of the United States. His campaign for reelection was run from his "Summer White House" on the grounds now known as Monmouth University.

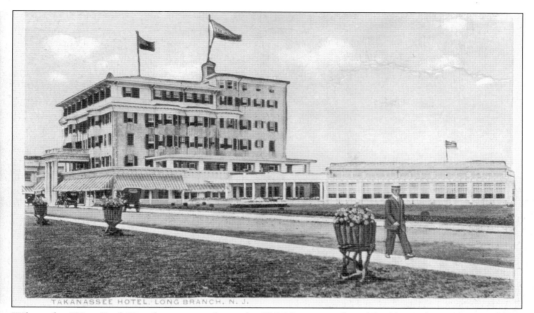

When the West End Hotel was torn down in 1906 it was replaced by the Takanassee Hotel. It was a six-story building and cost $300,000 to build. This was the last new hotel erected in Long Branch until several years after World War I. It was located on Ocean and Brighton Avenues.

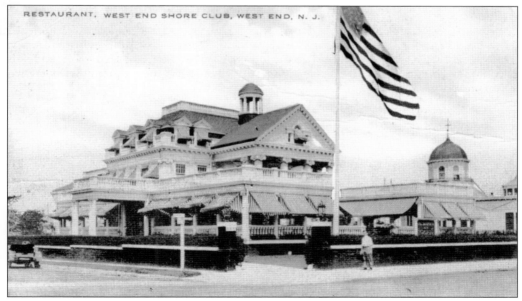

Dated 1922, this postcard shows off the popular restaurant known as the Shore Club. It was located on Ocean Avenue in West End.

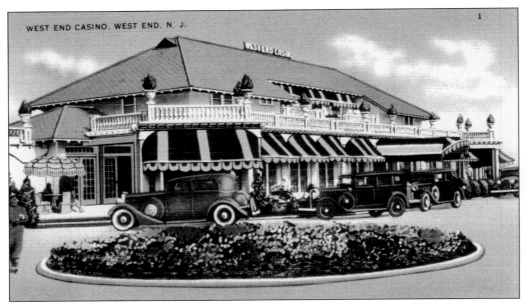

The West End Casino was a popular spot to enjoy the sun, surf, and socializing Long Branch had to offer in the early 1900s. It was one of the few private beach clubs along the ocean. Its members were offered cabanas with striped awnings, indoor swimming pools, and popular orchestras for evening entertainment.

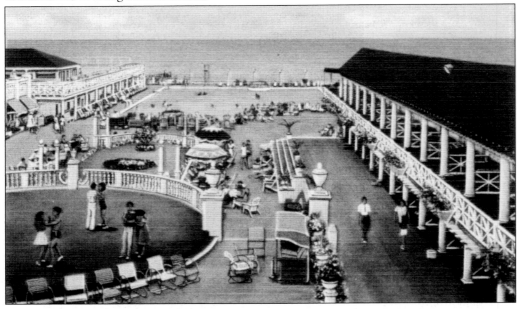

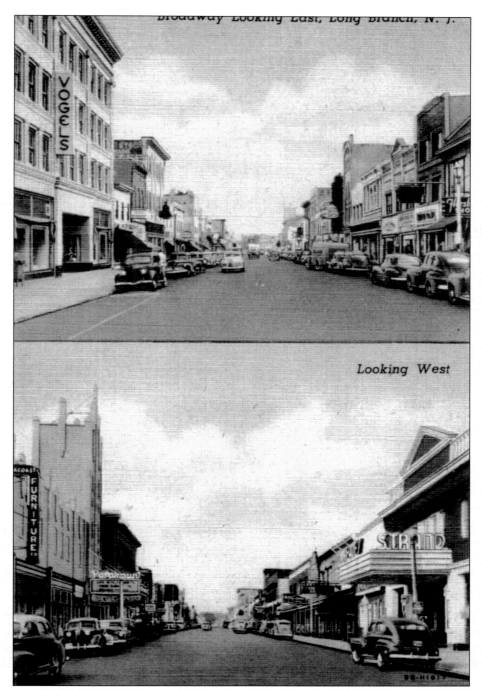

Looking West

This popular department store, Vogels, was a fixture on Broadway for many years. Several theaters were also located on lower Broadway in close proximity to one another. The Paramount and the Strand are pictured here. The oldest is the Strand and the most famous is the Paramount; once known as the New Broadway. These theaters had many uses: sometimes showing vaudeville acts, hosting Broadway try-outs, and putting the latest movies on the screen.

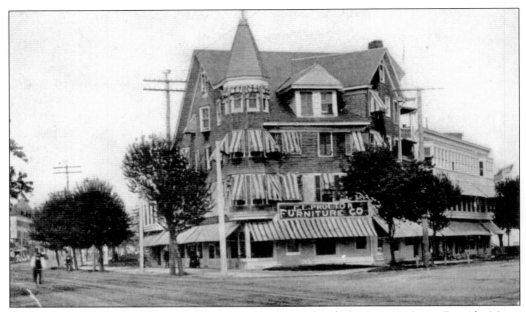

This is the C. F. Proctor furniture store, another example of a business in Long Branch. Many times the business owners lived above their stores and the whole family worked in the store.

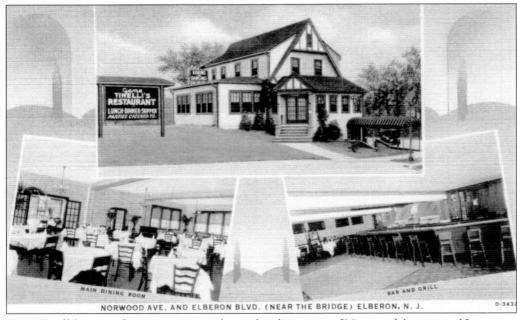

Gene Tinelli's, a popular restaurant, was located at the corner of Norwood Avenue and Lawrence Avenues in the southern section of Elberon. It is now a VFW lodge and looks much the same as it did in this undated postcard.

Something we do not really see out here.

Bathing at the Beach
LONG BRANCH, N. J.

Because they cost less to mail and gave the recipient an idea of the place the writer was visiting, postcards were a popular way of communicating in years gone by.

ACROSS AMERICA, PEOPLE ARE DISCOVERING SOMETHING WONDERFUL. *THEIR HERITAGE.*

Arcadia Publishing is the leading local history publisher in the United States. With more than 3,000 titles in print and hundreds of new titles released every year, Arcadia has extensive specialized experience chronicling the history of communities and celebrating America's hidden stories, bringing to life the people, places, and events from the past. To discover the history of other communities across the nation, please visit:

www.arcadiapublishing.com

Customized search tools allow you to find regional history books about the town where you grew up, the cities where your friends and family live, the town where your parents met, or even that retirement spot you've been dreaming about.